the JOY of SWImmING

A CELEBRATION OF OUR LOVE FOR GETTING IN the WATER

LISA CONGDON

FOREWORD BY LYNNE COX

CHRONICLE BOOKS

SAN FRANCISCO

Page 140 constitutes a continuation of the copyright page.

Library of Congress Cataloging-in-Publication Data available.

ISBN: 978-1-4521-4413-9

Manufactured in China

Designed by Kristen Hewitt

10 9 8 7 6 5 4 3 2 1

Chronicle Books LLC
680 Second Street
San Francisco, California 94107
www.chroniclebooks.com

Chronicle books and gifts are available at special quantity
discounts to corporations, professional associations, literacy
programs, and other organizations. For details and discount
information, please contact our corporate/premiums
department at corporatesales@chroniclebooks.com
or at 1-800-759-0190.

FOREWORD

LYNNE COX

There's something about the water that invites us to leap, jump, or dive in. And when we do, we are immersed in fun, in joy, and in love.

We love the way the water looks, the way it moves—its hypnotic patterns and variations in color. And we love the way it makes us feel—the way it releases us from the gravity of earth, lifts our bodies, minds, and spirits, and the way it invigorates us.

We love the sensation of water when we reach, pull, kick and breathe, and glide across it.

This is what we experience when we start paging through this book, *The Joy of Swimming: A Celebration of Our Love for Getting in the Water.* Lisa Congdon invites us in. We immediately realize that the book is open-ended, and free-flowing, much like water. We are free to explore it the same way we swim, float, bob, and play in water. We can gaze at one page, start in the middle, flip to the end, or skip around. It doesn't matter. Each page has something new, something engaging or inspiring to show us about the experience of getting into the water.

Lisa has written and illustrated a book that not only shares with us her gifts as an artist, but shares her love for swimming. She honors the swimmers and the swimming community who have made swimming one of the most popular and fastest-growing activities on the planet.

Like Lisa, I love swimming and the swimming community. I am a lifelong swimmer. I began swimming in a pond in Maine at six months old, took swimming lessons at the Y, joined a swim team, competed in public and university swimming pools, trained with two Olympic coaches, swam the English

Channel, the Bering Strait, in Antarctica, and across other great waterways between continents.

The stories and histories that Lisa relates inside these pages, and the vivid illustrations she has created to accompany them, convey the universal appeal of swimming. I find myself particularly drawn to her watercolor portraits of both heroic and everyday swimmers. I loved learning who these swimmers were; the challenges they faced; how they contributed to the sport, to society, and to the world, in ways both big and small.

From beautifully hand-drawn infographics and timelines putting the history of the sport in context, to the uniquely illustrated quotes and aphorisms decoratively placed through the book like pearls of wisdom, each image here is an exciting discovery. You'll learn about the evolution of what's worn for the sport with paintings of vintage goggles, suits, and swim caps. There are pictures of bright ribbons, medals, and trophies that remind us of our first swim meets, and those winning moments that we remember all of our lives. We discover swimming pools around the world, and famous swimming holes as well.

Lisa uses visual tropes and art-making techniques to evoke the magic of swimming. The colors in her paintings are rich and fully saturated, like the ocean at sunrise. She brings in wonderful vintage photos, splashed here and there throughout the book—pictures of people and from times gone by. There is light in their eyes and a sense of joy in their faces just to be near the water. They bring back memories of swimming friends from yesterday, the places where we swam together, and the good times we shared.

Lisa's enthusiasm for swimming is contagious. When we see her illustrations of swimming pools we imagine what it would feel like to swim across the bright blue rectangles on the pages, or how it would feel to swim around the cool curved pool edges. This book awakens a sense of adventure within us. We discover new things about the sport we love, and there are forgotten things we suddenly remember. It is pure fun, like water. Whether we are new to the sport or have been swimming all our lives, *The Joy of Swimming* invites us to dive in.

INTRODUCTION: MY SWIMMING STORY

LISA CONGDON

It was a beautiful California day during the summer of 1977, and Queen's "We Are the Champions" was blasting from someone's boom box. The Shadowbrook Splashers, my childhood swim team, had just won the championship

meet. We danced and screamed in victorious revelry—all of us barefoot, nine-year-olds and teenagers alike—our tan bodies clad only in faded team suits, our mouths red from eating cherry-flavored Jell-O blocks. These were the glory days of my childhood: the summers, the morning practices, the swim meets on Saturdays, the smell of chlorine in everything—especially my hair, straw dry and green from pool water.

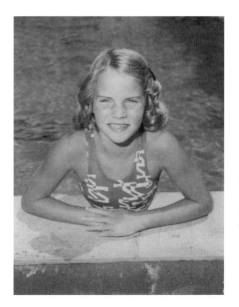

I lived for summers, and I spent nearly every available minute of them at the swimming pool down the block from my family's home in a suburban subdivision of San Jose, California's Almaden Valley. The pool was not only where I swam, but also where, over luxuriously long summer days, I played in the grass, made friends, ate lunch, read books, and where I learned about disco music and flirting and card games. It was where I first became independent and where I first became aware of my physical strength. And it was always where my mother could find me at the end of the day if I wasn't home in time for dinner.

Nearly 40 years later, my favorite place to be in the summer (or any time of the year if it is over 70-degrees Fahrenheit) is still an outdoor swimming

pool. The smell of chlorine, the feeling of rough poolside concrete under my bare feet, and the sound of water splashing are all so nostalgic for me that even now I am often transported back to the magic of my childhood simply by closing my eyes.

My love for swimming is so profound that I decided to write and illustrate a book about it. Here I share my fondness not just for the sport of competitive swimming, but also for recreational swimming—the playful dunking and splashing we did as kids and the meditative laps we swim to work out life's stresses. Here I pay homage to swimming's history and some of its great moments. Here I profile fellow living swimmers as young as nine and as old as 92, regular people for whom the water is a source not only of exercise, but of serenity and healing. Here I honor some of swimming's great heroes, some famous and some until now hidden from the spotlight. Here I recall the sounds, the smells, and the tactile sensations associated with swimming in pools, in ponds, and in the ocean. Here I pay tribute to the activity that has brought so many of us such tremendous joy.

I have been a swimmer since I was a small kid. In April 1976, when I was eight years old, my family moved from upstate New York to sunny San Jose, California. I'd taken swimming lessons already and expressed an interest early that first summer in California to join the neighborhood swim team. My mother took me straight down to the pool and registered me for my first official team sport.

I took to swimming like I took to eating: with a sort of relaxed devotion, as if it was my birthright to be in a swimsuit in 80-degree air next to a pool at all times. I was, in fact, so relaxed about competitive swimming that I never had the intense discipline to become a really fast swimmer as a kid. But being on the team did mean that I got to be in the water and hang out near the pool every single day, which was exactly where I wanted to be.

When I was 11 years old I eventually expressed to my parents an interest in swimming competitively year-round. I was an above-average swimmer, and even at that young age I knew that in order to get further above average, I'd need to work at it. My mother took me to my first practice after school at a more serious year-round team not far from our home. There I lasted only about a week, so exhausted after two hours of practice each day that I could

barely stay awake afterward to finish my fifth-grade homework. My parents were not at all pushy when it came to athletics so I chose not to continue. It wasn't until I was 17 that I began to endure, and eventually love, working hard at training—including the long hours, the exhaustion, and the endless hunger it brings. I have forever been impressed by children and teens who can work out in the pool before or after school and still engage fully in academics. It's no small feat.

When I was a freshman in high school I was confronted with the choice to join my school's team, and I decided that sleeping an hour later was more important than getting up and swimming before school every morning. I didn't swim on my school's team for the first three years of high school.

But then, during January of my junior year when I was 16 years old, I had a serious skiing accident that left me with a completely torn medial collateral ligament, major surgery, a long pin in my knee, a six-pound cast for several weeks, and a leg brace for months. My orthopedic surgeon and physical therapist recommended swimming and weightlifting as low-impact forms of daily therapy both to build back the muscle mass I'd lost and to loosen the freshly mended (though very tight) ligaments I'd torn. My family had moved to nearby Los Gatos, California, several years earlier, and my parents purchased a membership at the Los Gatos Athletic Club so that I could use the water and the weight room to recover from my injury.

It was that summer at the club's pool that I fell in love with swimming again. But this time it was in a new way, different than I'd experienced it as a younger kid. Sure, I luxuriated at the club's pool deck on warm days, but for the first time I also began to appreciate fully the health benefits of swimming, to experience the exhilaration of working hard at something physically challenging, and to find satisfaction in pushing myself to set and meet personal goals. That fall, at the beginning of my senior year, with my knee almost fully recovered, I finally joined the high school swim team and began swimming competitively for the first time in years. I approached it with a new vigor and discipline, going so far as to read books about the power of visualization and working out two times a day to increase my strength. At the end of that year's season, I placed second in the 50-meter butterfly sprint at the district championship meet—out-touched by the winner by only one one-hundredth of a second.

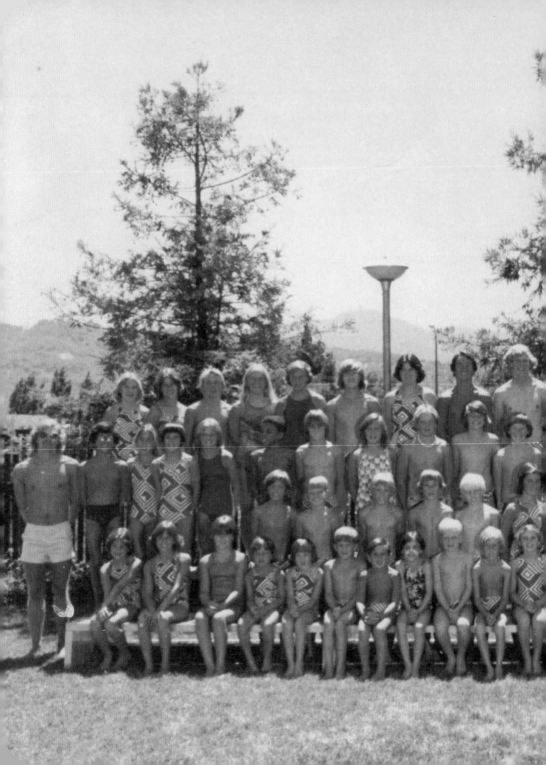

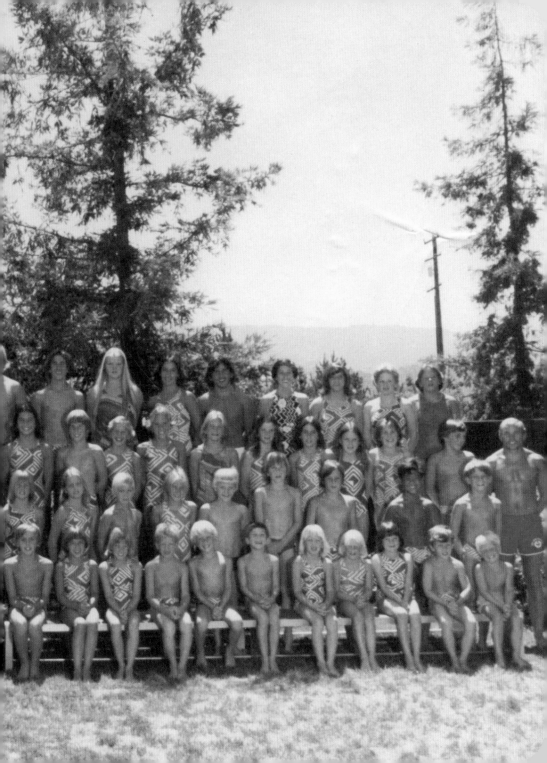

The next year I went off to college, and another swimming hiatus ensued—this time replaced by college stuff like parties and dates and studying. I graduated four years later, in 1990, and moved to San Francisco where I began swimming laps at the historic Chinatown YMCA on Sacramento Street after work. I swam at various pools in San Francisco during those years. And then in 1996, when I was 28, I heard about a gay and lesbian Masters swim team called the San Francisco Tsunami. In my early twenties I had come out as a lesbian, and I was looking not only to enlarge my circle of friends, but also to get back in the water in a more serious way. This seemed like the perfect opportunity. I had only recently learned of Masters Swimming. United States Masters Swimming (USMS) is a national membership-operated nonprofit organization that provides membership benefits to nearly 60,000 adult swimmers of all levels across the country on hundreds of local teams.

Like many people who approach Masters Swimming for the first time, I was nervous to attend my first practice. I hadn't swum competitively for nine years and wasn't sure I could hack it. Could I keep up? Would I still be able to race? I was also worried about joining a team. Was I going to fit in? Would people be welcoming? I decided it was worth a try. I gathered my courage and showed up to practice at Hamilton Pool on Post and Steiner to work out with the San Francisco Tsunami.

On that day, I fell in love with the Tsunami and Masters Swimming. For the first time in my adult life I felt part of something extraordinary. Not only did I experience the health benefits and exhilaration of regular rigorous swimming workouts again, but I met some of the people who would eventually become my second family: my teammates. I also became a better swimmer. By 1997, a year after joining the team, I was swimming far faster than I did in high school, a by-product of excellent coaching and swimming year-round. In 1999, I joined my team's coaching staff, the only female coach at the time. Over the course of 11 years, I traveled the world to compete in Masters Swimming competitions, including two Gay Games competitions in Amsterdam and Chicago.

A tall, thin, curly-haired woman named Cari joined Tsunami shortly after I did and quickly became my best swim buddy. We were just one year apart in age and swam at almost the same pace. Just a few months after we joined the team in 1997, we traveled to San Diego for our first Masters swim meet.

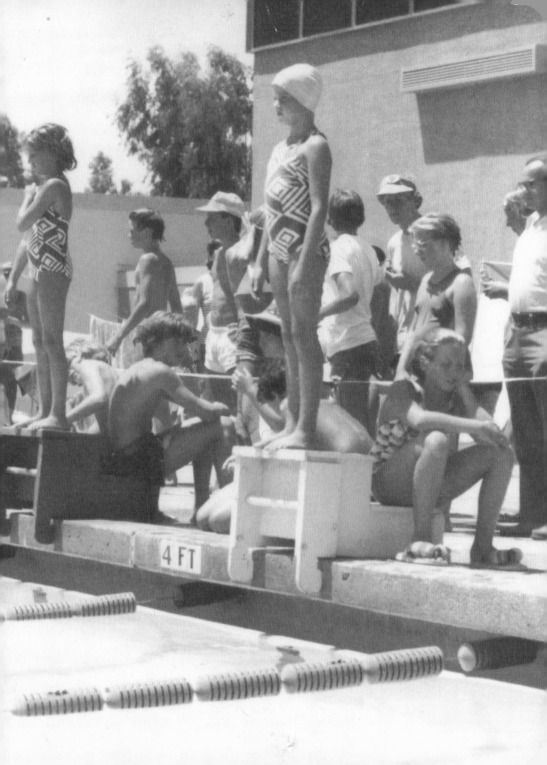

I was so excited (and nervous) about the competition that I literally did not sleep at all the night before the first day of the meet. But adrenaline (and a little Red Bull) saved me—I swam faster than I'd ever swum before, setting two personal bests, only to continue to better my times again and again over the next 11 years. Cari and I were so obsessed with swimming during those years that we would routinely tape any swim competitions that we could find on my VCR and watch the races together, rewinding and rewatching the most exciting parts.

Swimming also carried me through periods of intense heartache. In 2000, I ended an eight-year relationship that had gone terribly bad. I had lost so much weight due to depression after the breakup that I could barely find the strength to get to swim practice. But it was my fellow teammates who expected to see me each evening no matter how I was feeling, inviting me to dinner and feeding me. Those practices and dinners saved me. In early 2001 I used swimming as my motivation to begin to feel like myself again. I signed up for private work with Coach Geoff Glaser to rebuild my physical strength, improve my stroke, and work toward becoming a competitor in distance freestyle, a new goal at the time. By 2003 I had gained back the weight I'd lost and was a faster swimmer than I'd ever been, taking home several medals in both individual and relay events at the International Gay and Lesbian Aquatics (IGLA), including participation on a USMS record-breaking mixed relay team with Geoff and my friends and teammates Brad and Alissa.

Around 2006, after 11 amazing years, I came to a painful realization: I had to take a break from competitive swimming. The years of intense workouts and weekly coaching responsibilities were leaving me feeling tired. Simultaneously, making art had become my new passion and outlet and, increasingly, my new career. I decided that the Gay Games in Chicago that year would be my final event. It was a wonderful way to walk away, ending my swimming career on a high note: there I medaled in every event I swam, taking away six golds and three silvers.

I've never stayed out of the pool for long, and over the next 10 years, I kept swimming on my own on and off, the cold water always calling me back in. In 2015, my art career a steady and consistent force in my life, I felt called to begin swimming more rigorously again. I now get myself into the water for a good 3200–3600 yard workout at least three days a week, occasionally swimming with local masters teams.

There has always been a fixed and steady connection for me between art making and swimming. Both of these passions require similar things of me: enormous discipline and a unique form of endurance. They also provide motivation and direction in my life like no other pursuits. I learned that this connection is similar for many other artist/swimmers. When I began working on this book and sharing its progress on social media, scores of artists emailed me to let me know they were also swimmers. In her 2012 book *Swimming Studies*, artist and writer Leanne Shapton tells a beautiful and visceral tale of growing up a competitive swimmer and how, in part, that experience shaped her life as an artist. Reading Shapton's book was the first time I realized there was a connection between athletic and artistic discipline.

Like art making, swimming is at the same time a rigorous exercise and also a form of play. It is also for many people a source of energy, vitality, and healing—a theme you will see repeated again and again throughout this book. Water wakes us up and holds us in times of distress or change. It allows the awkward to move with grace, the heavy to feel light, and the disabled to feel accomplished. It is an emotional blanket in times of recovery and vulnerability. It is a form of movement that supports us no matter how large or small we are, how tall or short, how able-bodied or disabled.

In the words of swimming great Gertrude Ederle, "When we're in the water, we're not in this world." May this book provide you with a glimpse into the capacity of swimming to transform, to heal, to empower, to strengthen, and to provide transcendent joy.

GERTRUDE EDERLE

1905 - 2003

One of swimming's greatest, Gertrude Ederle was not only a triple medalist at the 1924 Olympic Games in Paris, this American swimmer was the first woman ever to swim across the English Channel. She did this in 1926 in 14 hours and 39 minutes. Her swim also smashed the men's record by over two hours. She maintained the women's record for over 25 years.

FAMOUS SWIMMING FIRSTS ♥

IN 1980, VLADIMIR SALNIKOV OF RUSSIA BECAME the FIRST SWIMMER EVER to COMPLETE the 1500 METERS IN UNDER 15 MINUTES IN 14:58.27.

IN 1964, DAWN FRASIER OF AUSTRALIA BECAME the FIRST to WIN GOLD IN the SAME EVENT FOR three CONSECUTIVE OLYMPICS. She WON the 100 FREE IN 1956, 1960 & 1964.

IN 1972, MARK SPITZ BECAME the FIRST PERSON to WIN SEVEN GOLD MEDALS IN ONE OLYMPIC GAMES: 100 & 200 FREE; 100 & 200 FLY; 4x100 & 4x200 FREE RELAYS; 4x100 MEDLEY RELAY.

IN 1964, DON SCHOLLANDER OF the U.S. WAS the FIRST SWIMMER TO WIN FOUR GOLD MEDALS IN A SINGLE OLYMPICS. HE WON the 100 & 200 FREE & WAS PART OF the WINNING 400 & 800 FREE RELAYS.

IN 1984, NANCY HOGSHEAD & CARRIE STEINSEIFER OF the U.S. REGISTERED the FIRST OFFICIAL tIE IN OLYMPIC HISTORY IN the 100 METER FREE. BOTH SWIMMERS REACHED the WALL IN 55.92.

IN 2000, ANTHONY ERVIN WAS the FIRST AFRICAN AMERICAN TO MAKE the OLYMPIC tEAM & WAS ALSO the FIRST TO MEDAL IN SWIMMING.

IN 2012, MISSY FRANKLIN WAS the FIRST WOMAN TO SWIM SEVEN EVENtS IN the OLYMPIC GAMES.

IN 2008, MICHAEL PHELPS WAS the FIRST TO WIN 16 tOTAL MEDALS: 14 GOLD & 2 BRONZE.

JOHNNY WEISSMULLER 1904 - 1984

Johnny Weissmuller is probably best known for playing Tarzan in films of the 1930s and 1940s, but his greatest accomplishments were most certainly in the pool. Weissmuller was one of the world's fastest swimmers of his heyday in the 1920s, winning five Olympic gold medals and even a bronze medal for water polo. He won 52 U.S. National Championships, set 51 world records and 107 American records. He was undefeated in official competition for the entirety of his swimming career. He was the first person to break one minute for the 100-meter freestyle. He set all of his records at a time when there were no starting blocks, no flip turns, and no modern pools with lane lines. He was the first Swimming Hall of Fame honoree.

JOHN MARKS 65 YEARS OLD

John started swimming at the age of six at the local YMCA. "It was a 20-yard, four-lane pool engulfed in a cloud of chlorine. There were usually 30-plus kids circle swimming in that small pool together," he says. In high school John began swimming distance freestyle and completed an AAU long-course (four-mile) swim. Shortly thereafter he went on to get a full-tuition swimming scholarship to Northwestern University. Now his love is open-water swimming. John's youngest daughter is also an open-water swimmer, and they've participated in several events together over the past 10 years. "I am happiest swimming in open water and prefer a routine of doing one-plus miles each workout. I have always counted strokes as a method of keeping track of my progress (i.e., 7 to 8 strokes = 25 yards) and now find myself counting strides when I walk for exercise, too."

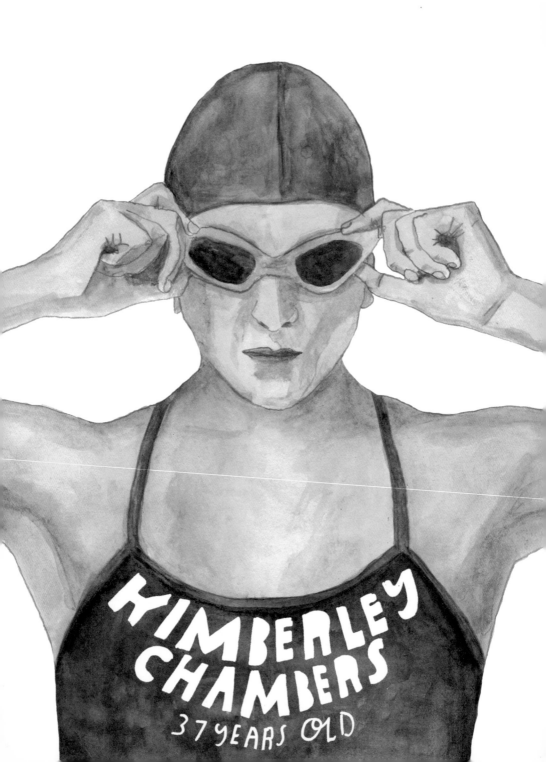

Kimberley was born in a small farming town called Te Kuiti in New Zealand. She moved to the United States when she was 17 years old to attend college at UC Berkeley. She learned to swim as a child in school, but didn't begin swimming regularly or have formal swim training until the age of 32. Two years earlier in 2007 after a freak accident in which she fell down a flight of stairs, doctors informed Kimberley that she had a 1 percent chance of walking unassisted again.

Diagnosed with acute compartment syndrome in her right leg, she refused amputation and decided to rehabilitate her leg.

As part of that quest, Kimberley began swimming for the first time since primary school. What is exceptional about her story is that shortly after she began swimming, she embarked on an unbelievable journey of distance open-water swimming. "I am a medical case study due to my remarkable recovery," she says. Within several short months after getting in the water, she swam from Alcatraz to Aquatic Park in San Francisco. In 2011, she became the first woman to participate in a relay swim from the Golden Gate Bridge to the Farallon Islands. Since then she has completed open-water swims around the world including relays across the English Channel and around Manhattan, and solo swims of Cook Strait, Lake Tahoe, Molokai Channel, and Tsugaru Strait in Japan. Kimberley follows all marathon swimming rules, wearing only a regular suit, latex cap, earplugs, and goggles. "There is no resting or touching the support boat," she adds.

In September of 2014, Kimberley successfully crossed the North Channel (Northern Ireland to Scotland), her seventh and final "Oceans Seven" swim. The Oceans Seven consists of seven of the toughest swims in the world. To date, only six people have finished the Oceans Seven, including Kimberley. "I love the adventure of the ocean. It is both exhilarating and terrifying. With each swim, I have been given a very unique opportunity to push myself in unimaginable ways. It is completely satisfying feeling emotions at such intensity and doing something that scares you. It's living."

CHEL MICHELINE
40 YEARS OLD

Chel was born with spina bifida, a serious neurological disease that develops in the womb. People with this disease experience muscular, skeletal, and nerve-based health issues. "I was categorized at birth as someone who would very likely be physically disabled," Chel says. "This never set well with me. Although I had a zillion health issues, I always wanted to be moving and felt like my body had more potential." Nothing she did seemed to agree with her body until she discovered distance swimming. When she was a freshman in college, Chel was diagnosed with a bone infection and had surgery. After she spent several months in bed to recover, doctors gave her permission to swim for rehabilitation. "I was desperate to stretch and move. I started swimming laps—10, then 50, then 100. It felt amazing, like I was flying! In the water, my body was fluid and graceful and strong!" Conversely, on solid ground, Chel was slow and had limited balance. "I emerged from the water every day exhausted, but exhilarated." And, miraculously, her body did not rebel. In fact, it did the opposite. "On land, when I got tired or pushed myself, my body would shut down." But as she added more laps, she just got stronger.

Muscles grew, and she was able to get off crutches. Her body became both more bulky and more lithe. "My body went from being this really scary, uncontrollable thing to something that I feel connected with in a deep way. Even though I have spina bifida, and things are wonky as a result, I LOVE my body."

About six years ago, Chel worked up to an amazing five miles a day. "Swimming is just what I do every day, like sleeping and eating and showering. When I travel, I swim. When I'm sick, I swim. The last time I skipped was during Hurricane Wilma, and I was back in the pool the following day, swimming around random bits of buildings and trees that had blown into the water." Chel needs to be in the water every day. "Every day when I get in the pool, I discover a new part of myself. And every day when I get out of the pool, I feel like a warrior. And after feeling like I was at the mercy of a disease for so long, being able to have these experiences and these emotions about the very same body that felt so out of control feels enormously profound. I can face whatever else the day brings knowing I just kicked ass for five miles. If nothing else, I swam."

VICTOR MALDONADO
39 YEARS OLD

Victor Maldonado was born in Changuitiro, Michuacan, Mexico, in 1976 and grew up in Livingston, California. "Growing up in central California meant taking every opportunity to find cold water to cool off during the summer," says Victor. As a kid Victor enjoyed recreational swimming in Livingston's municipal pool, his friends' pools, area lakes, rivers, and swimming holes around orchards. For the last 10 years, Victor has been swimming laps regularly about five days a week for 20 to 90 minutes, depending on what his schedule allows.

"I am drawn to the water by the physical challenge and sense of freedom I feel when I'm in the pool. Swimming helped me quit smoking ten years ago and has helped me sustain a healthy lifestyle ever since. More than providing me a full-body workout, my swims bring me a sense of mental calm and accomplishment."

SWIMMING TIMES

Vol. XIV. No. 4 June, 1936 Price 6d.

London Diving Club
(Affiliated to I.C.A.S.A.)

GALA
(under A.S.A. Laws)

'Pete' Desjardins

Winner of Olympic Games 1928, in both
Spring-board and High-board Diving Events

Opening Show .

On SATURDAY, 20th JUNE 1936,
Doors Open at 8 p.m. Commence 8.15 p.m.
at
THE MARSHALL STREET BATHS,
OXFORD CIRCUS, W.I.

Reserved Seats Standing Only
2 6 and 1/10 1 6
(including tax) (including tax)

Also Club Diving and Swimming Championships

General Hon. Secretary:
G. MATVEIEFF, 43, Clarence Gate Gardens, N.W.I.

SYLVIA ROSE.

SWIMMING TIMES

SURFOPLANES
IN FINCHLEY OPEN AIR POOL

Every important Pool needs Surfoplane. Swimmers and non-
swimmers can use and enjoy them. They add colour and sport
wherever used and are a source of profit to Pool authorities
and owners. Surfoplanes are untouched by swimmers Municipal
and Private Pool owners as the most popular during now
offered to Bathers. Full particulars from
SURFOPLANES LTD., 32 Victoria St., Westminster, S.W.1
Phone: Victoria 8616
Write early and ensure delivery for the Whitson Holiday.

Vol. XIV. No. 3. May, 1936. Price 6d.

SWIMMING TIMES

HAROLD "DUTCH" SMITH, the Highboard Diving Champion
of the World will be touring the British Isles from 18th August,
1936, under the auspices of the Highgate Diving Club.

Vol. XIV. No. 2, April, 1936. Price 6d.

THE SWIMMING TIMES

June, 1935.

SWIMMING STADIUM
West Street
BRIGHTON

The LARGEST COVERED SEA WATER
SWIMMING POOL in the WORLD.

165-ft. long, 60-ft. wide, Diving Stage up
to 30 Metres. International Standards.

The Home of Swimming. Divers' Paradise.
Swimming Times — All Day—
Saturdays till 7.15 p.m.
Polo, Diving, Swimming Races,
Galas, every Saturday at 7.45.

First Class Private Baths.
Fresh Water — Sea Water —
Medicated — Zotofoam
Poolside Buffets for Light
Refreshments.
Fully Licensed Restaurant and Lounges.
Popular Prices.

S.S. BRIGHTON
AS FRESH AS THE SEA BUT SAFER

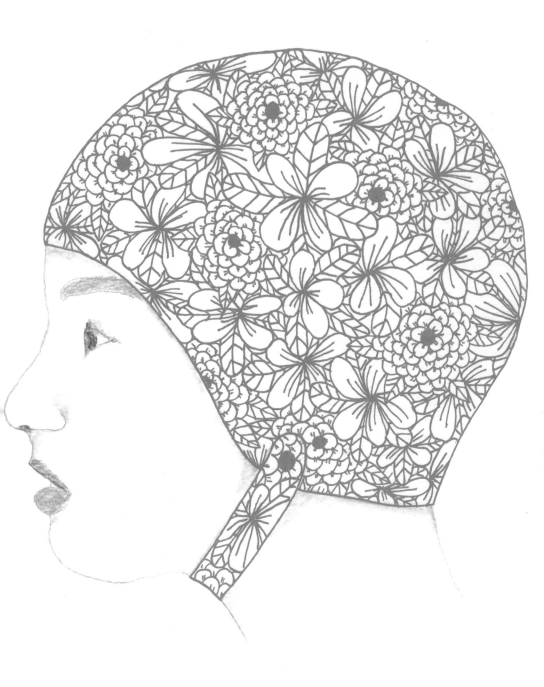

SARAH "FANNY" DURACK 1889 - 1956

Sarah Frances "Fanny" Durack was an Australian competitive swimmer. From 1910 until 1918 she was one of the world's fastest female swimmers, accomplished at all distances. For a period of time she held every women's swimming world record from 100 meters to a mile. Durack and fellow swimmer Mina Wylie were initially denied permission to compete in the 1912 Stockholm Olympics. They were later allowed to go provided they paid their own expenses. There, Durack set a new world record in her first heat of the 100-meter freestyle. She then won the final, becoming the first Australian woman to win an Olympic gold medal in a swimming event.

ESTHER WILLIAMS

1921- 2013

Esther Williams started her swimming career as a teenager, setting national swimming records as part of the Los Angeles Athletic Club swim team. The war prevented her from competing in the 1940 Summer Olympics, so she instead joined Billy Rose's Aquacade Show, which was based in San Francisco. While in the city, she spent several months training alongside Olympic gold-medal winner and Tarzan star Johnny Weissmuller. As part of the Aquacade, she caught the attention of Hollywood talent scouts. After appearing in several minor film roles, she made a series of films in the 1940s and 1950s known as "aquamusicals," featuring synchronized swimming, for which she is best known today.

WOMEN'S BATHING SUITS OVER the 20th CENTURY

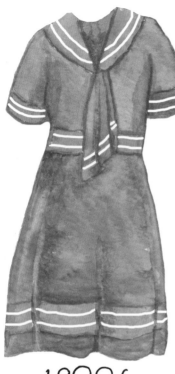

1900s

1940s 1950s 1960s

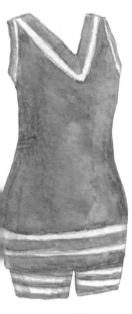
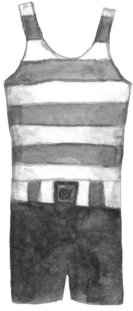
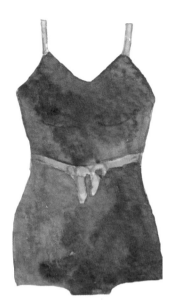

1910s *1920s* *1930s*

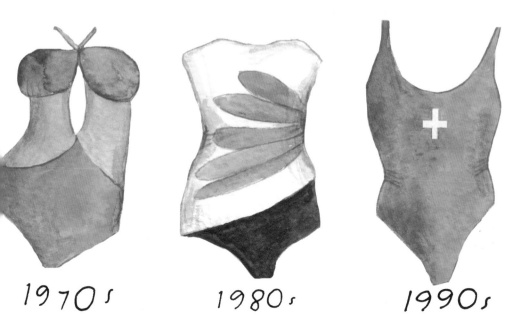

1970s *1980s* *1990s*

THE BIKINI

LOUIS RÉARD, Its INVENTOR

BEFORE the BIKINI, ALL TWO-PIECE SUITS SHOWED ONLY A SMALL PART OF the MIDRIFF.

IN 1946, LOUIS RÉARD, A FRENCH AUTO ENGINEER, LAUNCHED A TWO-PIECE SWIMSUIT, WHICH HE CALLED the "BIKINI."

HE NAMED the BIKINI AFTER the BIKINI ATOLL NUCLEAR tests.

A BRIEF HISTORY

At first widely shunned, by the late 50s early 60s the bikini rose in popularity.

Knitted suit from 70s ↩

"String" bikini popularized by models like Cheryl Tiegs ↙

At first, Réard couldn't get model to wear his design. So nude dancer Micheline Bernardini was the first to wear it. It was so small it could fit into a matchbox.

Today, athletes like volleyball players & swimmers wear specially designed bikinis.

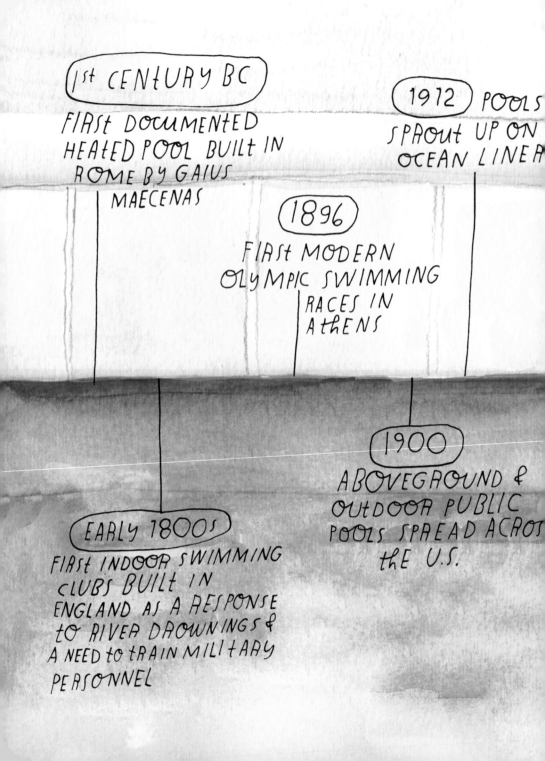

1st CENTURY BC

FIRST DOCUMENTED
HEATED POOL BUILT IN
ROME BY GAIUS
MAECENAS

1912 POOLS
SPROUT UP ON
OCEAN LINER

1896

FIRST MODERN
OLYMPIC SWIMMING
RACES IN
ATHENS

1900

ABOVEGROUND &
OUTDOOR PUBLIC
POOLS SPREAD ACROS
THE U.S.

EARLY 1800s

FIRST INDOOR SWIMMING
CLUBS BUILT IN
ENGLAND AS A RESPONSE
TO RIVER DROWNINGS &
A NEED TO TRAIN MILITARY
PERSONNEL

A VERY BRIEF HISTORY OF the SWIMMING POOL

WORLD'S LARGEST POOL BUILT IN CHILE

(2006)

(2012)
THERE ARE 10 MILLION POOLS IN the U.S. ALONE

(1950s)
HOLLYWOOD HIGHLIGHTS the POOL AS A GLAMOROUS STATUS SYMBOL & UNIQUE POOL DESIGNS BECOME MORE POPULAR

tHE "GREAt BAtH"

tHE GREAt BAtH At MOHENJO-DARO IS tHE FIRSt KNOWN PUBLIC BAtH.

tHE FLOOR IS WAtERtIGHt DUE tO FIttED BRICKS LAID WItH PLAStER & tAR.

tHE FIRST PUBLIC SWIMMING POOL
3RD CENTUAY BC

Its AUINS still stAND IN PAKIStAN, DISCOVERED BY ARCHAEOLOGISts IN 1926.

SCHOLARS AGREE the POOL WAS MOStly USED FOR RELIGIOUS PURPOSES to PURIFY the SOULS OF the BATHERS.

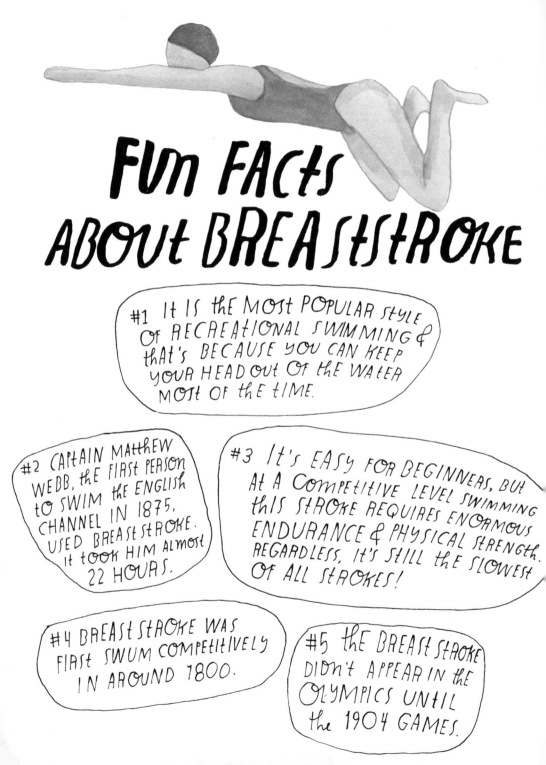

Fun Facts About Breaststroke

#1 It is the most popular style of recreational swimming & that's because you can keep your head out of the water most of the time.

#2 Captain Matthew Webb, the first person to swim the English Channel in 1875, used breaststroke. It took him almost 22 hours.

#3 It's easy for beginners, but at a competitive level swimming this stroke requires enormous endurance & physical strength. Regardless, it's still the slowest of all strokes!

#4 Breaststroke was first swum competitively in around 1800.

#5 The breaststroke didn't appear in the Olympics until the 1904 games.

Pastor Bob started swimming when he was five or six. "It took me three years of lessons to put my head under the water. I finally learned in a bathtub," he remembers. In 1997 in his hometown of Grinnell, Iowa, Bob was injured in a hit-and-run car-on-bike accident that left him a paraplegic. Bob, who had been a competitive swimmer in both high school and college, returned to the water after his accident, first to a seniors water aerobics class, and then eventually back into competitive swimming. In 2011, Bob competed in the Revolutions 3 Ironman Triathlon, finishing in $15\frac{1}{2}$ hours, ahead of about 10 percent of the able-bodied field. "The following year I started looking at Paralympic swimming times in my best event, the breaststroke, and discovered I wasn't far from a competitive time." He started training with a coach and within six months he had sliced 20 seconds off a one-minute event. "I beat the American record for the 50-yard short course breaststroke in my disability division (SB5) by four seconds." Before his incomplete L1 spinal cord injury, Bob enjoyed swimming as cross-training for cycling and running, but that changed following his injury. "Now I find the water to be the great equalizer. I returned to the pool as soon as my open wounds healed up and found that I was perfectly capable, not disabled, in the water. I can swim with the pack in the big triathlons. Swimming returns a great sense of normality and accomplishment to me."

ICELANDIC SWIMMING POOLS

THE NATURAL WONDER OF GEOTHERMAL ENERGY (NATURALLY HEATED WATER FROM THE GROUND) IS WHAT MAKES HEATING POOLS IN ICELAND SO EASY!

POOLS ARE EVERYWHER IN ICELAND. PRACTICALLY EVERY CITY, TOWN, & TINY VILLAGE HAS AT LEAST ONE FULLY STAFFED PUBLIC SWIM COMPLEX. IF THE POOL IS IN GEOTHERMAL AREA, IT'LL LIK BE OUTSIDE. SOME COLDER AREAS HAVE INDOOR, ELECTRICALLY HEATED POOLS

HOT TUBS ARE EVERYWHERE & NOT JUST AT POOL COM-PLEXES! THEY ARE AN IMPORTANT PART OF THE CULTURE. MOST SUMMER HOMES & MANY RESIDENTIAL HOMES HAVE HOT TUBS.

IN MOST POOL COMPLEXES YOU MUST TAKE OFF YOUR SHOES AS SOON AS YOU STEP THROUGH THE DOOR.

ICELANDIC POOLS ARE SOCIAL CENTERS. MOST PEOPLE DON'T ACTUALLY SWIM LAPS! THEY COME TO RELAX & HANG OUT. YOU MIGHT ALSO FIND PEOPLE SPENDING TIME WITH THEIR KIDS, ON DATES, OR EVEN HAVING BUSINESS MEETINGS IN THE POOL!

SHOWERS ARE MANDATORY & ARE REQUIRED BEFORE PUTTING YOUR SUIT ON. THERE IS A SPECIAL REQUIREMENT TO USE SOAP WHEN YOU SHOWER AT ICELANDIC POOLS. THIS IS IMPORTANT BECAUSE ICELANDIC POOLS USE LITTLE OR NO CHLORINE.

PREPARE TO SEE NAKED PEOPLE OF THE SAME SEX WHEN YOU ENTER THE LOCKER ROOM. LOCKER ROOMS ARE WIDE OPEN & SHOWERING NUDE IS REQUIRED!

THE ICELANDIC WORD FOR "SATURDAY" IS LAUGARDAGUR & MEANS "POOL DAY." THAT'S HOW IMPORTANT POOLS ARE TO ICELANDERS.

NEW YORK CITY HAS 25 TIMES THE POPULATION, BUT HALF AS MANY SWIMMING POOLS!

ALWAYS TAKE A SHOWER & DRY OFF BEFORE GOING BACK IN THE LOCKER ROOM. GETTING THE LOCKER ROOM FLOOR WET IS A NO-NO!

VINTAGE GOGGLES

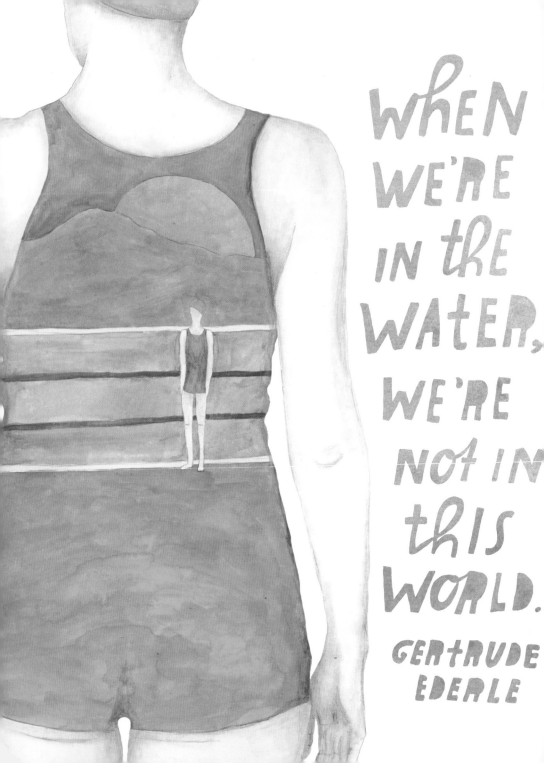

WHEN WE'RE IN THE WATER, WE'RE NOT IN THIS WORLD.

GERTRUDE EDERLE

DUKE KAHANAMOKU

1890 - 1968

Duke Kahanamoku was a Hawaiian-American competitive swimmer and surfer. In 1912, he went with the U.S. team to the Stockholm Olympics, and he won Hawaii's first Olympic gold medal for 100-meter freestyle, and a silver medal for the 4×200-meter freestyle relay. Eight years later at the 1920 Antwerp Olympics, he won two gold medals in 100-meter freestyle and 4×200-meter freestyle relay. He was a beloved figure and helped to popularize swimming and surfing across the world, traveling to both swimming and surfing exhibitions over the course of many years.

ARE YOU JEALOUS GENEROSITY? YOU REFUSE TO ANYONE? FISH SACRED LIQUID IN THEY SWIM HUGE FLUID FREEDOM. RUM

OF the OCEAN'S
WHY WOULD
GIVE this JOY to
DON'T HOLD the
-UPS!
the

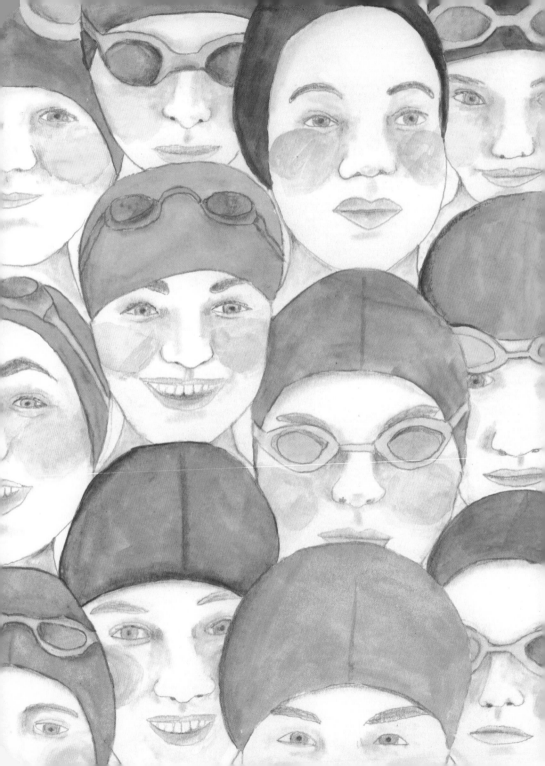

DORI MILLER
44 YEARS OLD

Dori has been swimming since she was five years old and remembers when it was a big deal to swim a lap of the pool on her own. When she was 11 she joined her local team in Connecticut and then competed in high school and college. After college she took 11 years off, but got back into swimming when she was 34. In 2006, Dori entered her first long-distance open-water race, the Boston Light Swim. After that, she was hooked. In 2008 she swam the English Channel for the first time. "It was a surreal experience to swim in the middle of the night. When I landed in France, I felt like I could keep swimming."

After a shoulder injury and one failed attempt, she completed a double crossing of the Channel in 2014 in 26 hours and 21 minutes.

MODERN

LONG-DISTANCE SWIMMING BEGINS WITH LORD BYRON'S CROSS OF THE HELLESPONT FROM EUROPE to ASIA.

LORD BYRON SWAM IN HOMAGE to LEANDER, WHO, AS GREEK MYTHOLOGY tELLS US, SWAM NIGHTLY ACROSS THAT STRETCH to VISIT HIS LOVER.

FINA
FÉDÉRAtION INtERNAtIONA DE NAtAtION

RULES GOVERN OPEN WATER SWIMMING. RULE StIPULAtE that SWIMMER CANNot USE FLOtAtION DEVICES, INSULAtED MAtERIALS, OR ANY ARtIFICIAL BREAthING AIDS. SWIMMERS ARE ALLOWED BOAt ESCORtS WITH GPS, FOOD, AND LIQUIDS.

DANGERS OF LONG-DISTANCE SWIMMING

1. SHARKS
2. JELLYFISH
3. SURF
4. HYPOthERMIA
5. OVERHEAtING
6. EXtREME DEHYDRAtION

10 KILOMETERS
thE DISTANCE OF thE MARAthON SWIM IN thE OLYMPICS & ALSO thE MINIMUM DISTANCE FO LONG-DISTANCE SWIMMIN

thE 10-KILOMETER OPEN WATER SWIM W INtRODUCED AS AN OLYMPIC EVENt FOR BO MEN & WOMEN IN 200

FUN FACTS ABOUT LONG-DISTANCE SWIMMING

DIANA NYAD BROKE the WORLD RECORD FOR THE LONGEST SWIM WHEN SHE SWAM 103 MILES FROM CUBA to FLORIDA IN 2013 At the AGE OF 63. It WAS HER 5th AttEMPt At tHE SWIM, HER FIRST WAS IN 1978 At tHE AGE OF 28.

THE TRIPLE CROWN OF DISTANCE SWIMMING:

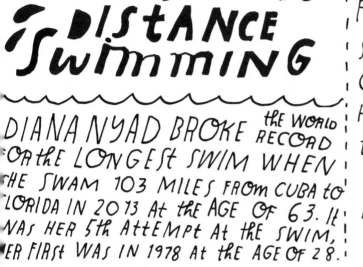

① tHE ENGLISH CHANNEL 21 MILES

② CAtALINA ISLAND to CALIFORNIA 20 MILES

③ AROUND MANHAttAN 28.5 MILES

IN 1875

CAPtAIN MAttHEW WEBB WAS the FIRST MAN to SWIM the ENGLISH CHANNEL. HE COMPLEtED tHE SWIM IN 22 HOURS.

APPROXIMAtELY 1912 PEOPLE HAVE SWUM ACROSS the ENGLISH CHANNEL, LESS tHAN HALF tHE NUMBER Of PEOPLE WHO HAVE SUCCESSFULLY CLIMBED MOUNt EVEREST!

HOW FAST CAN HUMANS REALLY SWIM?*

POLAR BEAR
6.2 MPH

DOLPHIN
20 MPH

SEA OTTER
5.6 MPH

FAST HUMAN
4.5 MPH

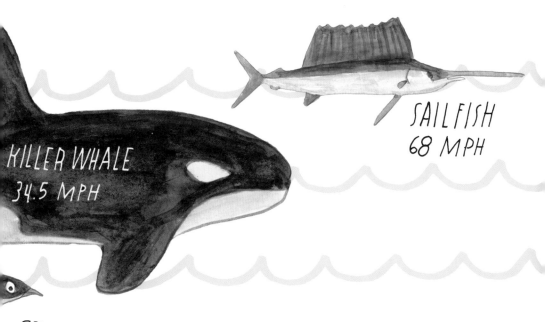

SAILFISH
68 MPH

KILLER WHALE
34.5 MPH

GENtoo PENGUIN
22 MPH

*tURNS OUt, COMPARED tO
OtHER ANIMALS WHO SWIM,
NOt VERY FASt! EVEN tHE
FAStESt MALE SWIMMERS
ARE SLOWER than SEA OttERS.

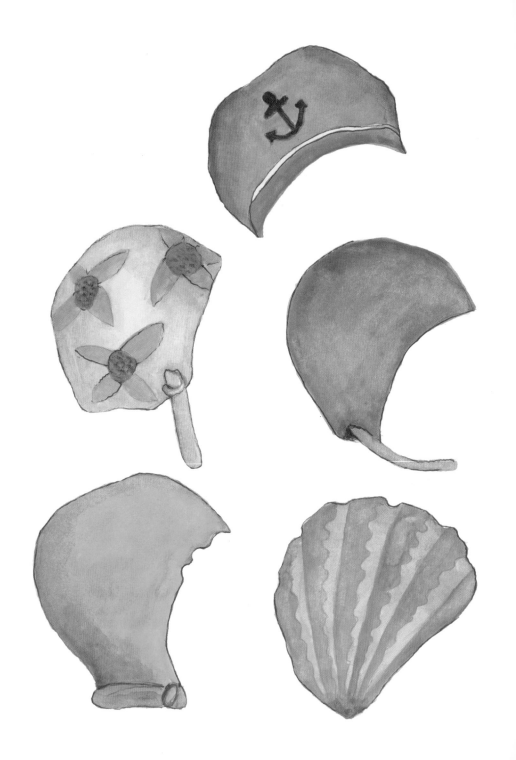

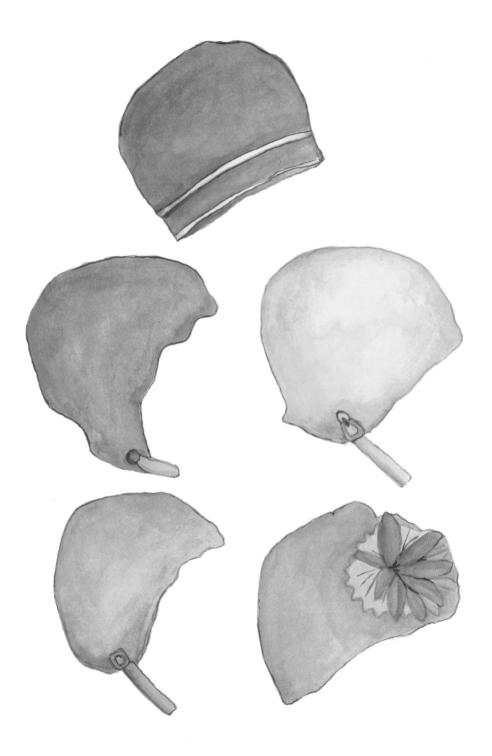

JEFF COMMINGS 41 YEARS OLD

Jeff's mother signed him up for swimming lessons when he was four years old. The swimming lessons made Jeff good enough for the swim team at the boys club in St. Louis, Missouri, when he was five. "I would spend the day at the Boys Club in the summer. If I wasn't in the library reading, I was playing in the pool. I never wanted to play basketball games or just run around the playground. I was completely in my element in the pool, and that remains true to this day." Jeff competed in his first meet when he was six, and he placed sixth in the 25 butterfly. "I still have the trophy somewhere in storage!" Jeff swum competitively for years. He was part of the USA Swimming national team from 1989 to 1994 and has a myriad of other accomplishments, including as a nine-time All-American at the University of Texas, winning a bronze medal in the 100 breaststroke at the 1991 Pan American Games, and qualifying to swim in three U.S. Olympic Trials. In 2007 he and Geoff Glaser started the Dolphins of the Desert Swimming Academy in Tucson, Arizona, and now part of his life is dedicated to helping others become more accomplished swimmers. "I love swimming because it is equally an individual sport and a team sport. When I am swimming, the cares of the world stay on the deck. I focus on the task at hand and often feel a little rush of energy after a workout. But mostly, it feeds my competitive nature and allows me to stay fit as I get older."

GREAT MOMENTS IN

1896

Swimming is first featured in the Olympic program. The first events were freestyle & breaststroke.

Backstroke is added as an Olympic sport.

1904

1908

At the London games, swimmers swam for the first time in a pool with organized rules. Previously, events were held in open water.

Women's events wear added to th games in Stockholm.

1912

OLYMPIC SWIMMING

1922

BUTTERFLY WAS ADDED TO THE GAMES IN MELBOURNE.

1972

THE 10 K OPEN WATER MARATHON DEBUTS IN BEIJING.

JOHNNY WEISSMULLER ECAME THE FIRST ERSON TO SWIM E 100 METER EE IN UNDER A MINUTE.

1956

MARK SPITZ WON & SET RECORDS IN ALL SEVEN OF HIS EVENTS & BECAME THE MOST SOUGHT-AFTER MAN IN ADVERTISING.

2008

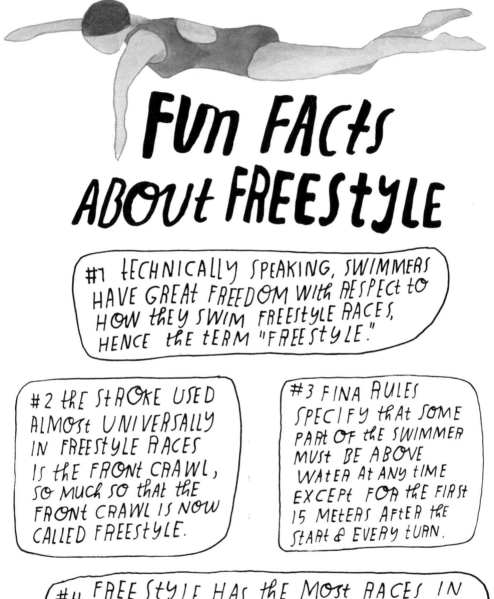

FUN FACTS ABOUT FREESTYLE

#1 TECHNICALLY SPEAKING, SWIMMERS HAVE GREAT FREEDOM WITH RESPECT TO HOW THEY SWIM FREESTYLE RACES, HENCE THE TERM "FREESTYLE."

#2 THE STROKE USED ALMOST UNIVERSALLY IN FREESTYLE RACES IS THE FRONT CRAWL, SO MUCH SO THAT THE FRONT CRAWL IS NOW CALLED FREESTYLE.

#3 FINA RULES SPECIFY THAT SOME PART OF THE SWIMMER MUST BE ABOVE WATER AT ANY TIME EXCEPT FOR THE FIRST 15 METERS AFTER THE START & EVERY TURN.

#4 FREESTYLE HAS THE MOST RACES IN COMPETITION: 50 M, 100 M, 200 M, 400 M, 800 M, 1500 M, 4x50 RELAY, 4x100 RELAY & 4x200 RELAY. WHEW!

Charlie Daniels is an American competitive swimming legend. At the 1904 Olympics in St. Louis, Missouri, Daniels became the first American to win an Olympic medal, winning gold medals in both the 200- and 400-meter freestyle races. He was an eight-time Olympic medalist and world-record holder of his time. He retired from swimming in 1911 with 53 national titles and wins in over 300 races. Daniels is credited by many with inventing the "American" front crawl (now known as freestyle), perfecting the Australian crawl by adding a six-beat kick. Daniels was inducted into the International Swimming Hall of Fame as an "Honor Swimmer" in 1965.

CHARLIE
DANIELS
1885 - 1973

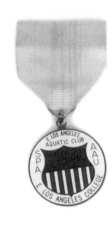

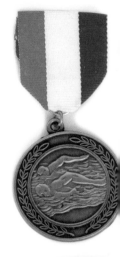

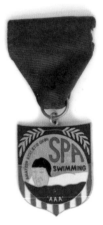

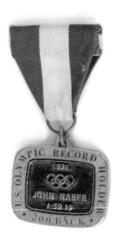

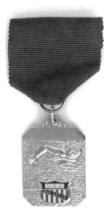

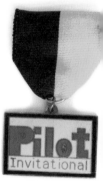

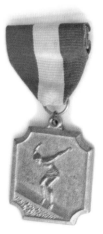

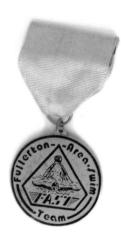

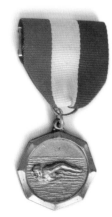
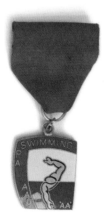

"I have cerebral palsy, which makes it hard for me to walk and do things others take for granted, like buttoning shirts or tying shoelaces." Alex's mom got Alex into the public baths as a baby in Germany where he was born. "I liked the feel of the warm water although I was scared at first." Alex started swimming lessons at the local YMCA in Maine where he lives now when he was five. "I hated it at first. My mom made me go in, and I cried a lot. Then I felt safer in the water and started to enjoy it." When he was 10, Alex joined the Pen Bay Sailfish swim team and has been swimming with them every year since then. "I swim three times a week, but sometimes I feel lazy and don't want to, but then my parents make me!" Alex jokes. "My favorite thing to do in the water is just float around and move at my own pace. I love feeling weightless. In the water I can move around without struggling all the time and I like that." Cerebral palsy leaves Alex's muscles tight, and swimming helps to keep them loose and also keeps him fit. "My mom says that I have a special smile that I only have in the water. I guess I am pretty happy there."

ALEXANDER JUREK 15 YEARS OLD

THE ANATOMY OF THE SWIM PARKA

WATER-RESISTANT POLYESTER EXTERIOR

SYNTHETIC FAKE FUR OR FLEECE THAT NEVER REALLY ABSORBS THE WATER

LONGER THAN ANY OTHER COAT YOU OWN

WARM, SLIGHTLY LARGE HOOD FOR COLD DAYS

NAME + TEAM NAME ON BACK

POCKETS FOR FOOD, MONEY, KEYS, OR GOGGLES

TOO BIG FOR EVEN LARGE PEOPLE

AMANDA COMMODORE

13 YEARS OLD

Amanda has lived her entire life in Tacoma, Washington, and is a member of Lummi Nation, one of the federally recognized Native American tribes in the United States. One day when Amanda was in fourth grade she decided that she wanted to start swim lessons. "After I completed all the levels with Swim America I went up to the next level . . . swim team!" She swims with a team called Ohana. "They've become my second family, and the pool is my second home. My coaches believe in me and always encourage me. Coach Dan reminds us that we have great physical ability, even when our minds are ready to quit."

Amanda's favorite strokes are breaststroke and freestyle. "They're both so calming and enjoyable, unlike the butterfly. I am not very fond of the fly." Amanda says that out of all of the sports swimming is the only one that she feels confident in. "Sometimes I have to be pushed, but I always enjoy it and want to challenge the clock."

Mike started swimming at age four and competitively by the third grade. "In fifth grade I started getting really chubby. It started getting real awkward, so I worked my butt off to be faster than everyone else." He even qualified for Junior Olympics but broke his arm a month before the competition. His competitive swimming career ended. Then, at the age of 29, Mike decided that it was time to get back in the water several days a week to swim and surf. "Water is the only thing that has been able to keep my interest." Mike says swimming and surfing help center him, work out his anger, and keep a more positive perspective on life. "Swimming and surfing keep me at the top of my game. It sounds hokey, but they are almost like religion. They help me find peace and understanding."

MIKE JETER
31 YEARS OLD

NEWtON'S thiRD LAW STATES that FOR EVERY ACTION thERE IS AN EQUAL & OPPOSite REACtION. thIS EXPLAINS HOW SWIMMERS MAKE It ACROSS thE POOL.

WAtER IS 773 tIMES MORE DENSE & 55 tIMES MORE VISCOUS (thICK) thAN AIR. thIS DENSITY IS CALLED "DRAG."

A StROKE PULLING BACK PUSHES thE BODY FORWARD.

thERE ARE thREE tYPES OF DRAG: COLLISION (WAtER MOLECULES COLLIDING WIth SWIMMER); FRICtION (BEtWEEN WAtER & HUMAN BODY); AND WAVE DRAG (tURBULENCE GENERAtED BY thE SWIMMER).

SWIMMING CAN BE BROKEN INtO tWO PLANES: HORIZONtAL AS A SWIMMER'S ARM & LEGS PROPEL AGAIN thE FORCE OF DRAG, VERtICAL, AS A SWIM MER'S WEIGHt IS OPPOSED BY BUOYAN

OF SWIMMING

SWIM FASTER BY REDUCING DRAG: STREAMLINED BODY POSITION, CONTROLLED MOVEMENTS, TIGHT SUITS, SWIM CAPS & SHAVING BODY HAIR.

VELOCITY IS SPEED IN A PARTICULAR DIRECTION. SWIMMERS LOSE SPEED BY CHANGING DIRECTION FREQUENTLY. FLIP TURNS ALLOW SWIMMERS TO MAINTAIN MOMENTUM AS THEY CHANGE DIRECTION.

A DOWNWARD KICK PROPELS THE BODY UP.

EVERYONE "FLOATS" AT A DIFFERENT LEVEL, AND THAT DEPENDS ON BODY FAT (FAT FLOATS BUT MUSCLE & BONE DO NOT), LUNG SIZE, AND WHETHER YOU ARE SWIMMING IN SALT OR FRESH WATER (SALT WATER IS MORE DENSE & EASIER TO FLOAT ON).

HAVING STRONG CORE MUSCLES HELPS SWIMMERS TO BALANCE IN THE WATER SINCE THEY ARE SUSPENDED & HAVE NO BASE FOR BALANCE AS LAND ATHLETES HAVE.

BE NOT the SLAVE

OF YOUR

PLUNGE INto the

DIVE DEEP AND SWIM

COME BACK WITH

With NEW

that SHALL EXPLAIN

AND

OWN PAST.

UBLIME SEAS,

AR, SO YOU SHALL

ELF - RESPECT,

OWER, WITH AN

DVANCED EXPERIENCE

OVERLOOK the OLD.
RALPH WALDO EMERSON

JEFF STUARt 54 YEARS OlD

"They say I was two weeks old when I first got into the water. I know that by six months old, I was crawling out of the crib and plopping into the water on my own. There are aging lifeguards who can attest to that, and some photos as well!" He soon began playing in the pool daily and by age four was competing in the six-and-under category at his father's swim club in East Hartford, Connecticut. Jeff has been swimming regularly for 53 years and has never stopped, except for a one-year stint in prison due to problems with drug and alcohol addiction. Jeff has been clean and sober ever since and often helps others with similar issues through swimming. He literally spends most of his life in the water, sometimes coaching three times a day in three or four separate bodies of water—including pools, lakes, rivers, and the sea. Jeff has an enormous number of swimming accomplishments, including as a top AAU swimmer as a kid in the 1970s, an Olympic trial finalist in the 1980s, two Masters world records in butterfly in 1996, and countless open-water champion titles from the last decade. "I honestly feel that the true role that water plays in my life is untold. The nature of it and its relationship to my being cannot be described. The value, the essence, the import and impact, this precious nature which water holds is far beyond any other substance on our planet. It has been a serene place of comfort to me."

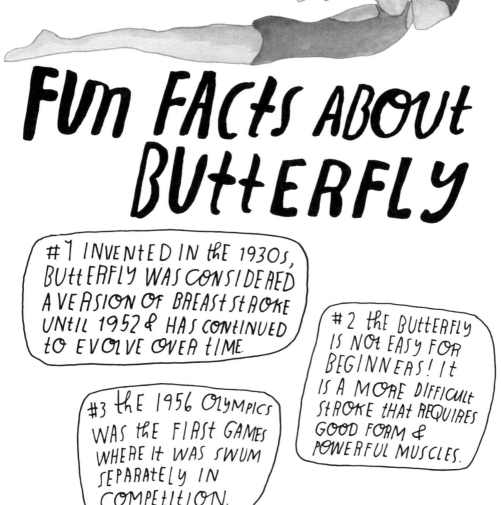

Fun Facts About Butterfly

#1 INVENTED IN THE 1930s, BUTTERFLY WAS CONSIDERED A VERSION OF BREASTSTROKE UNTIL 1952 & HAS CONTINUED TO EVOLVE OVER TIME.

#2 THE BUTTERFLY IS NOT EASY FOR BEGINNERS! IT IS A MORE DIFFICULT STROKE THAT REQUIRES GOOD FORM & POWERFUL MUSCLES.

#3 THE 1956 OLYMPICS WAS THE FIRST GAMES WHERE IT WAS SWUM SEPARATELY IN COMPETITION.

#4 MANY BUTTERFLY SWIMMERS BREATHE EVERY OTHER STROKE. AT HIGHER LEVELS, BREATHING EVERY STROKE IS JUST AS FAST, HOWEVER. MICHAEL PHELPS IS AN EXAMPLE OF A SWIMMER WHO BREATHES EVERY STROKE & SWIMS BUTTERFLY AT RECORD SPEEDS.

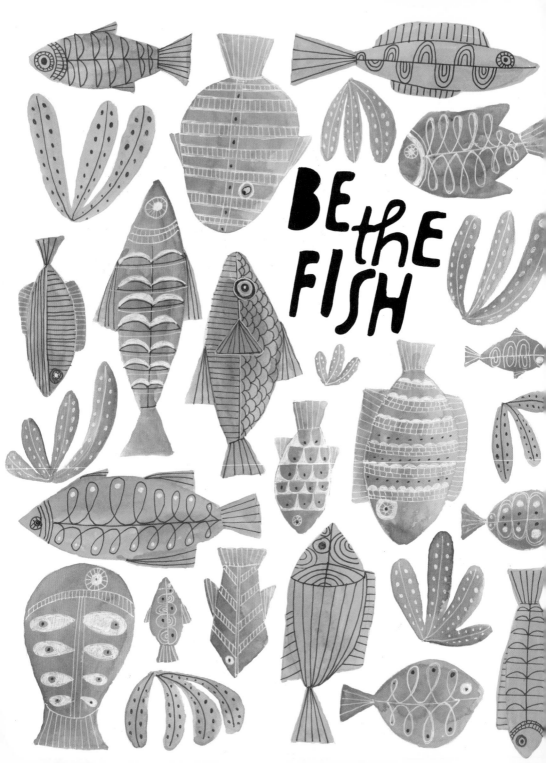

MAI LE 41 YEARS OLD

The youngest of five children, Mai was born during the Vietnam War, in Bien Hoa, outside of Saigon. Her family was evacuated during the last days of the war and relocated to the Los Angeles area when Mai was one year old. She grew up going to beaches, lakes, and rivers with her family, but she didn't really start lap swimming until she was in her mid-thirties. Mai has been swimming regularly since 2007, even when she travels abroad. Ironically, the act of swimming is not easy for Mai. "I'm slow, and it always feels like an effort, but swimming also puts me in a meditative state, what people call 'flow.' Often, it feels like swimming is the only self-propelled thing I do that changes my body's relationship to gravity."

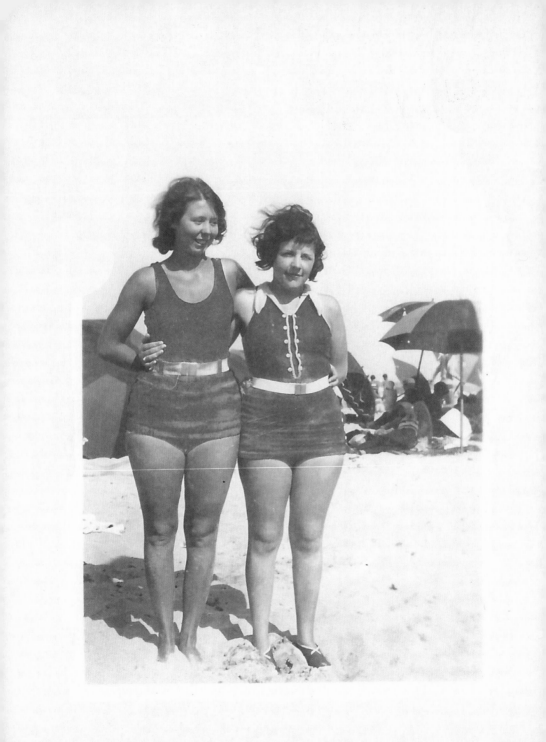

ANNE DITMEYER 33 YEARS OLD

Anne Ditmeyer is an American living in Paris and a lifelong swimmer who swam competitively from childhood to high school. Anne loves swimming so much that she tolerates the notorious crowds at Parisian pools, even though it's sometimes hard to get in a good swim. She lives for the two-week school break that happens every six weeks, when the public pools are open all day and are much less crowded.

"Swimming in Paris is an adventure," says Anne. "I always compare going to the pool in Paris to dealing with French bureaucracy. The hours are very limited, and the lanes are extremely crowded. I once had 19 people in a 25-meter lane!" While her workout sometimes suffers, Anne's swims are a creative release where her ideas can percolate. "I get my best ideas in the pool!" She also entertains herself by writing stories about the pool in her head, which she one day hopes to write down. "The other perk of Paris pools is that my hair loves the chlorine here; the water in France is much harder than in the United States, but I always have the best hair days after I swim." Anne has visited and swum in all 39 public pools in Paris.

PARIS PISCINES

THERE ARE 39 PUBLIC POOLS IN PARIS, FRANCE. HOURS ARE LIMITED, SO ALWAYS CHECK BEFORE VISITING. ENTRY IS 3€ & YOU RECEIVE A ticket THAT YOU GIVE TO AN ATTENDANT OR YOU GO THROUGH A TURNSTILE.

POOLS CLOSE IN THE MIDDLE OF THE DAY FOR SCHOOL GROUPS MANY PEOPLE TAKE ADVANTAGE OF "VACANCE SCOLAIRES" (SCHOOL HOLIDAYS) WHEN POOL ARE OPEN ALL DAY.

THE "VESTIAIRE"

(LOCKER ROOM) IS OFTEN CO-ED. BRING 1€ COIN FOR SOME LOCKERS; OTHERS HAVE SELF-LOCKING "CABINES" OR THERE IS A COAT CHECK-STYLE ATTENDANT.

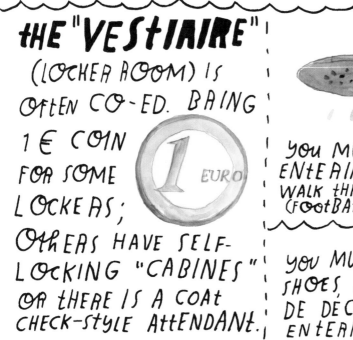

YOU MUST SHOWER BEFORE ENTERING THE POOL & WALK THROUGH THE "PEDILUVE" (FOOTBATH)

YOU MUST REMOVE YOUR SHOES IN THE "ZONE DE DÉCHAUSSAGE" BEFORE ENTERING THE LOCKER ROOM

"BONNETS" (SWIM CAPS) ARE REQUIRED FOR BOTH MEN & WOMEN. TIGHT-FITTING SUITS ARE REQUIRED FOR MEN. NO SWIM TRUNKS ALLOWED!

POOLS IN PARIS ARE 25 M, 33 M OR 50 M LONG. EXPECT TO SHARE YOUR LANE WITH AT LEAST 10 OTHERS.

NEVER FEAR! CAPS, SUITS, & GOGGLES ARE ALL FOR SALE IN **VENDING MACHINES!**

ALL POOLS ARE DRAINED ABOUT TWO TIMES A YEAR. THIS IS CALLED "VIDANGE."

MANY POOLS IN PARIS ARE HISTORIC & QUITE BEAUTIFUL! SOME HAVE ODD PROPORTIONS & THE SHALLOW END IS SO SHALLOW, YOU MIGHT NOT WANT TO DO A FLIP TURN!

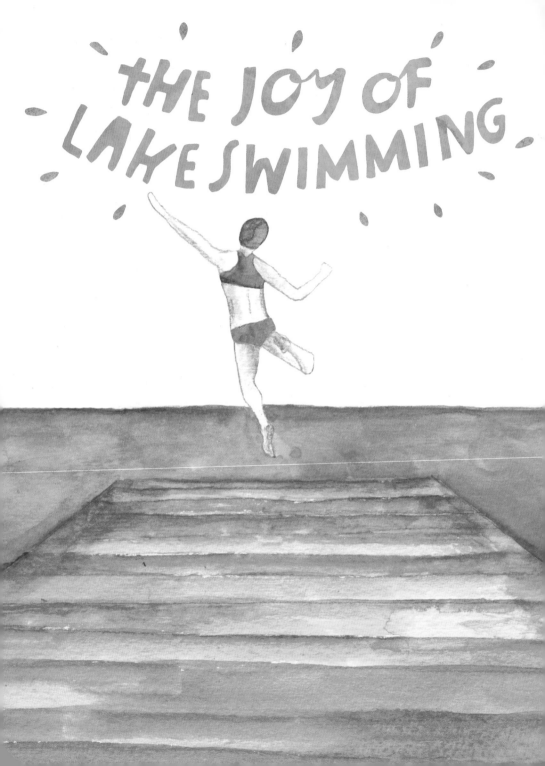

THE JOY OF
LAKE SWIMMING

BEVERLY DUBRIN
73 YEARS OLD

Beverly has swum three days a week since 1981. Though she had no formal swim lessons, she learned as a kid playing at the beach. For most of Beverly's life, swimming was for fitness and recreation, but 18 years ago when she was 54 years old, she joined the Walnut Creek Masters swim team. "I had never swum competitively before but joined the team when they added a workout at the same time that I was just swimming laps on my own." When Beverly was 56 years old, shortly after she joined the team, she was diagnosed with breast cancer. "When I was being treated for breast cancer, it was swimming that kept me going after surgery and during my chemotherapy and radiation treatments." Swimming was the one activity of her "normal" life that she would not let go, and it gave her a healthy support group. "At the time of my cancer, I knew very few people who had had breast cancer. I felt like my swim buddies went through my cancer with me." Beverly could not imagine her life without swimming. "Swimming and the water are my salvation. When I've had an injury, illness, or surgery, it is getting back into the water that speeds my recovery and sense of well-being."

JAKKI MOXON
64 YEARS OLD

Jakki grew up mainly near Manchester, United Kingdom, and has lived in Wrexham, Wales, since 1972. Since their retirement, Jakki and her husband Phil have spent their winters in Almerimar, Almería, Spain. In the 1950s, Jakki's parents took her family caravanning to the South of France. "I was six and loved the sea from the first moment. The Mediterranean is very buoyant, so I learned to swim almost without being aware of it, and have loved swimming ever since." Jakki never had lessons, but took to it naturally. "I think I enjoyed it so much because I was a podgy child, in the days before there were many fat children around, and I was useless at any other sport," she recalls. "In the water I was as light as air and as agile as my skinny friends and brothers." Jakki's dad also loved to swim, and it was a special activity they shared throughout her childhood and into adulthood. "The last time he swam, just a few weeks before he died, was with me, when I came to visit him for the first and last time, here in Almerimar, where he spent his winters." Her father left his small Spanish flat by the sea to Jakki, and she kept up his tradition of winter swimming.

Jakki has swum nearly every day for the last 10 years, and before that at every opportunity. "I swam through my five pregnancies, and swam 30 lengths of an Olympic-size pool when I was in labor with our fifth, our daughter. Not surprisingly, she likes swimming too!" When she is in the United Kingdom, Jakki swims regularly in the local swimming pool. "In Spain, I swim in the sea almost every day." If the sea is too rough or

if there are jellyfish, Jakki swims in the outdoor pool of a local hotel.

After a recent fall that injured her arm, Jakki sent for a special protective cover from the United Kingdom and managed to keep swimming, with one arm floating in its little bag. "I just love the water," says Jakki. "I like to see it, smell it, and, above all, feel it. I especially love it when it is cold, and I can see snow on the mountains, but the sun is warm. It makes me feel alive, in harmony with nature, and as if my body is young, supple, and beautiful. It eases any tension, relaxes me, gets things into perspective, makes me glad to be alive and count my blessings."

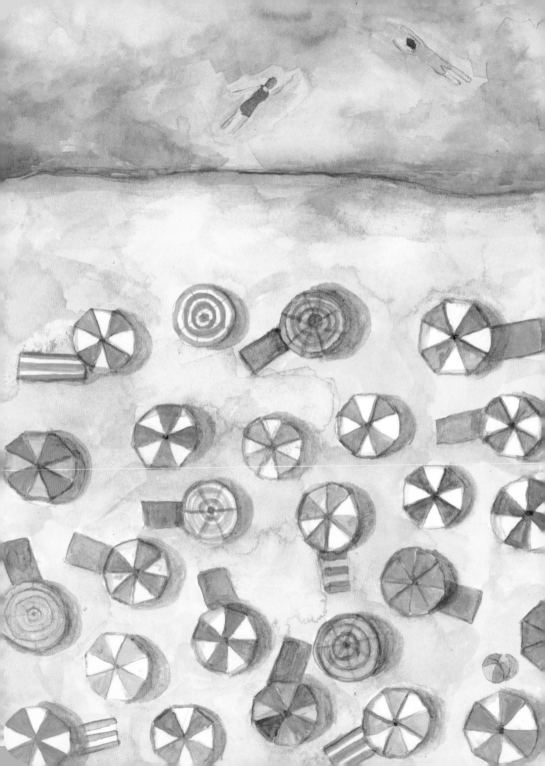

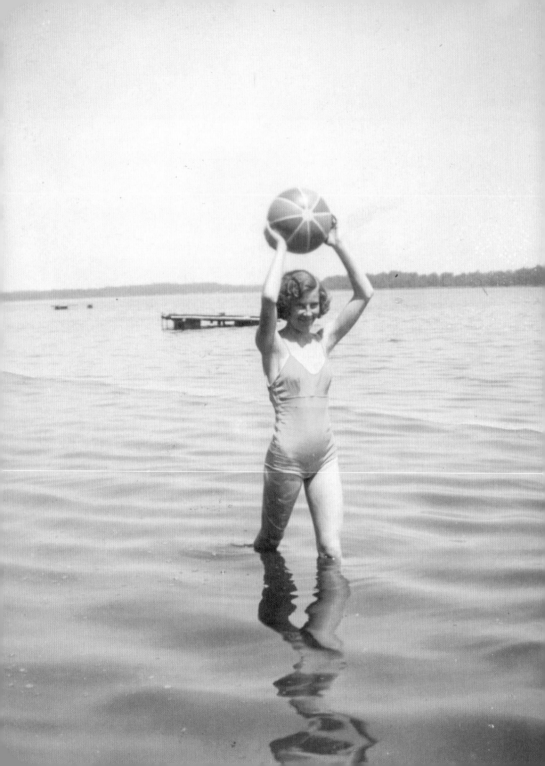

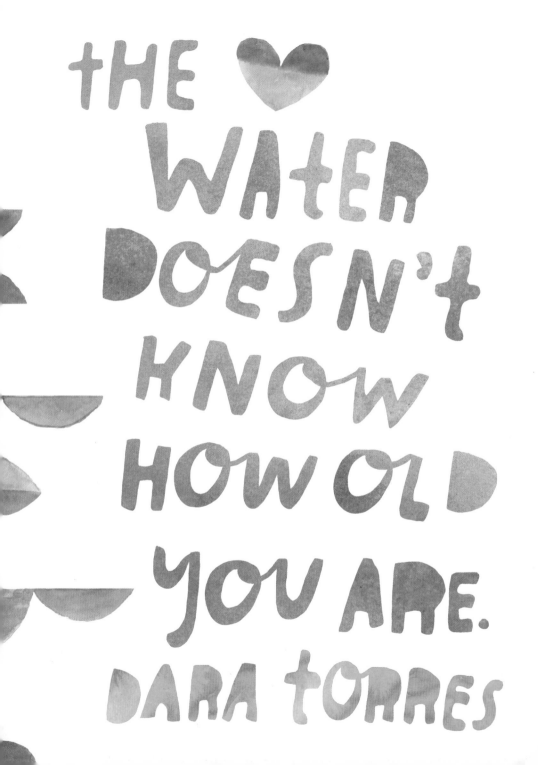

THE ♥ WATER DOESN'T KNOW HOW OLD YOU ARE.

DARA TORRES

Paul, who now lives in Ireland, learned to swim at around eight years old in Hale's Brook, a stream that empties into the Concord River in Lowell, Massachusetts. "There's a shopping mall there now." One of his earliest memories of swimming was saving his younger brother Jerry from drowning that same year. "Some kids took him in over his head. I had to swim to the bottom and kept scooping him up to the surface to get air until someone came out and helped me pull him to shore." Paul didn't start swimming regularly until 30 years ago when he retired. "I swim every Monday, Wednesday, and Friday at Aura Leisure Centre in the town of Carrick-on-Shannon in the County of Leitrim in Ireland. I always liked swimming. I enjoy floating on the surface. It keeps me alive! It keeps me in shape and active."

PAUL CRYAN

92 YEARS OLD

ADRIENNE PIPES
80 YEARS OLD

"I have always loved the water. Before I could walk I would crawl into the lake and laugh when the small boat waves would break over my head." Adrienne swam as a kid, but never competitively. In 1972, when she was 38 and after her kids were no longer toddlers, she joined a Masters swim team (USMS was brand new at the time). Adrienne has been swimming with Masters regularly for 43 years. "I have competed in so many meets I couldn't begin to count." She has competed as far away as Japan, Australia, and Italy. Adrienne loves the water because she finds it so healing. "Stress and uncomfortable feelings just seem to melt away as you float so effortlessly. The ocean and the pool take you to another dimension, and the exercise kicks in those endorphins that make you feel better all day." When Adrienne's partner died suddenly she was devastated. "Only the pool and ocean could take away the pain," she recalls. "I could never live where I was away from the water."

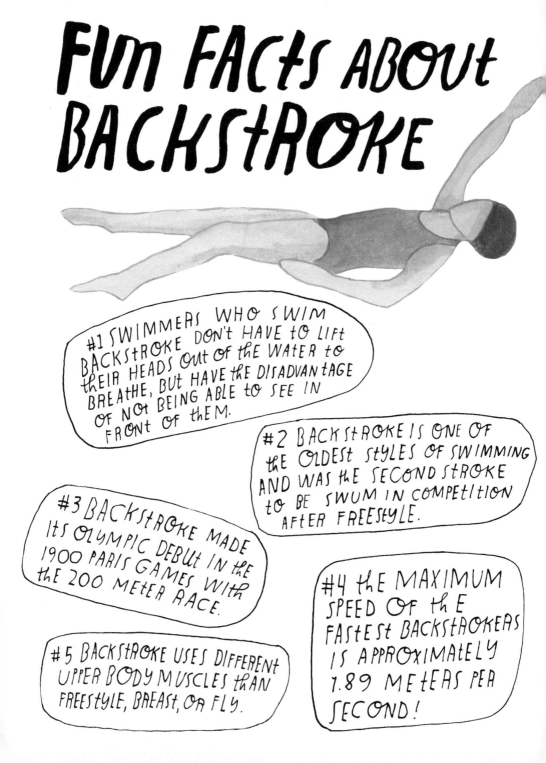

CALEB & ZION LEVY

9 YEAR OLD FRATERNAL tWINS

Caleb was introduced to swimming by his mother Donna and he began swimming competitively when he was seven years old. "Everyone calls me Flash because I'm fast," Caleb says. "I love swimming because I am really good at it, and I like competing and meeting new people." Caleb's favorite strokes are the breaststroke and the butterfly.

Shortly after Caleb joined the swim team, his twin sister Zion followed. "Everyone thinks I'm older because I'm taller, but he's actually older by one minute!" Zion likes swimming because it helps her stay in shape for soccer and track, which she also enjoys. "I also like swimming because I've become very good." Her favorite strokes are breaststroke and backstroke.

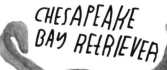

CHESAPEAKE BAY RETRIEVER

SOME DOGS WHO ARE GREAT SWIMMERS

MEDIUM & LARGE SIZED BREEDS WHO HAVE WEBBED FEET and WATER-RESISTANT COATS ARE OFTEN STRONG SWIMMERS!

IRISH WATER SPANIEL

PORTUGUESE WATER DOG

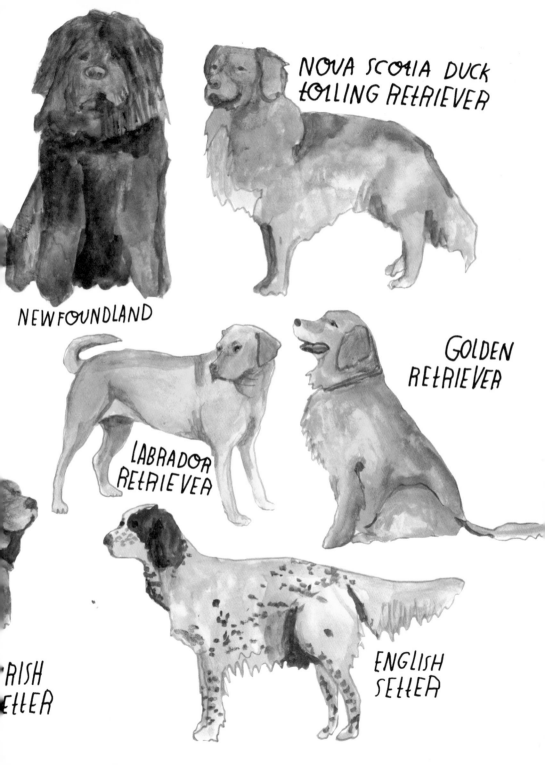

NEWFOUNDLAND

NOVA SCOTIA DUCK TOLLING RETRIEVER

GOLDEN RETRIEVER

LABRADOR RETRIEVER

RISH ETTER

ENGLISH SETTER

WHAT IS A SWIMMING HOLE?

A SWIMMING HOLE IS A DEPOSITORY OF WATER — USUALLY PART OF A RIVER, STREAM, CREEK, SPRING OR AT THE BASE OF A WATERFALL — WHICH IS LARGE & DEEP ENOUGH FOR PEOPLE to ENJOY SWIMMING. SWIMMING HOLES ARE DIFFERENT than OCEANS OR LAKES, AS thEY ARE USUALLY PART OF FRESH, MOVING WATER. NUDE SWIMMING IS A WELL-ESTABLISHED tRADItION IN SOME SWIMMING HOLES. MANY SWIMMING HOLES ARE IN REMOtE AREAS & ARE OFtEN ACCOMPANIED BY A LONG ROAD tRIP OR CAMPING

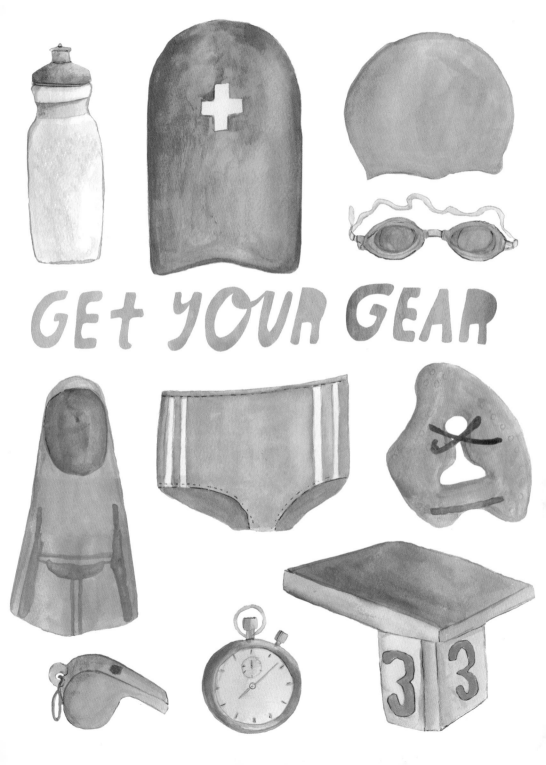

GET YOUR GEAR

SWIMMING POOL RULES

1) SHOWER BEFORE ENTERING

2) NO RUNNING ON DECK

3) PROPER SWIMWEAR REQUIRED

4) NO PETS

5) NO GLASS, FOOD, OR DRINK

6) NO ROUGH HORSEPLAY

7) SUPERVISE YOUR CHILDREN

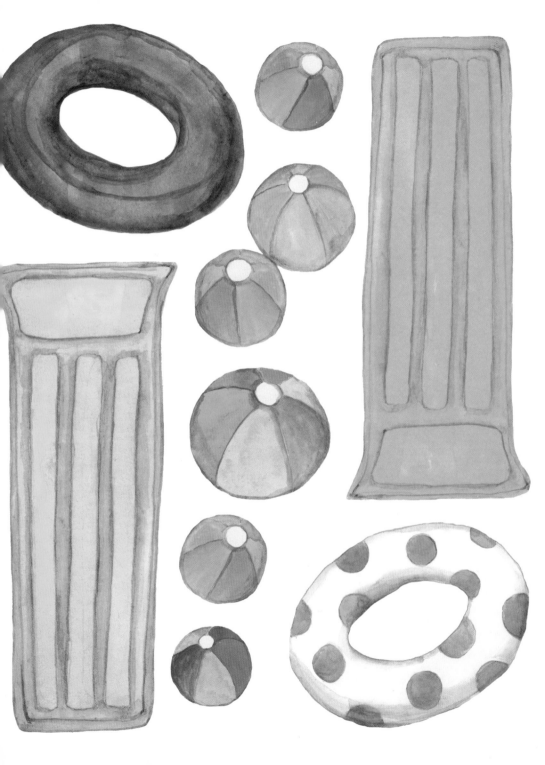

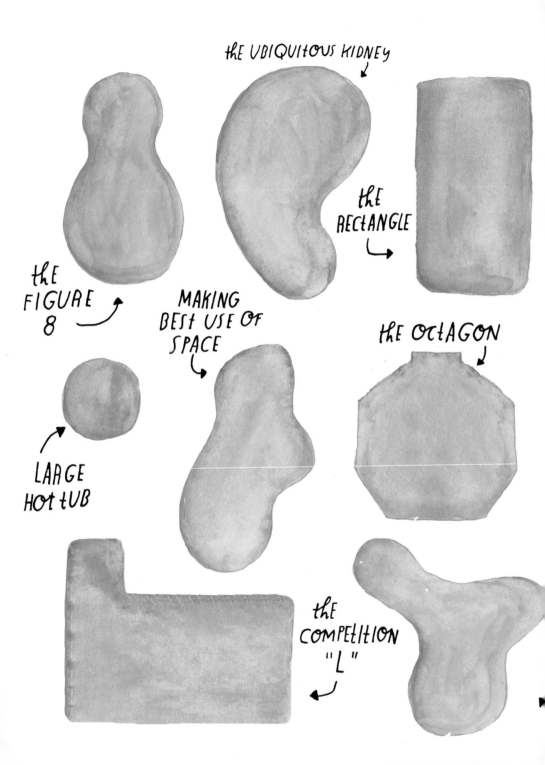

THE UBIQUITOUS KIDNEY

the RECTANGLE

the FIGURE 8

MAKING BEST USE OF SPACE

THE OCTAGON

LARGE HOT tUB

the COMPETITION "L"

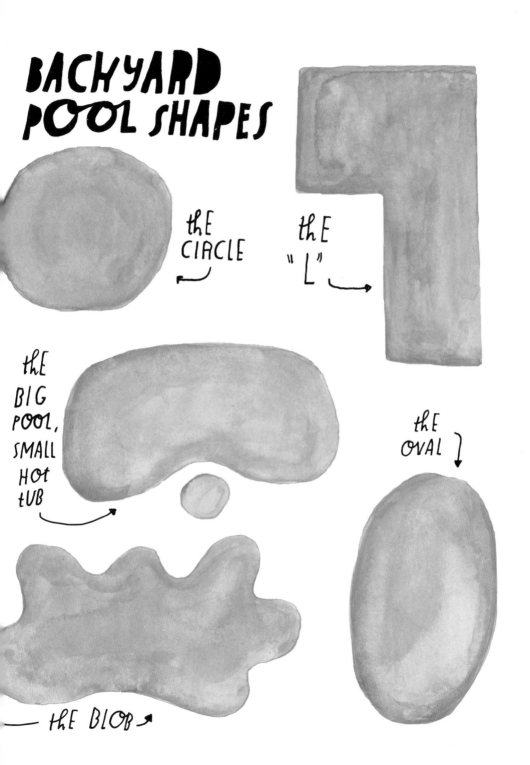

BACKYARD POOL SHAPES

thE CIRCLE

thE "L"

thE BIG POOL, SMALL HOt tUB

thE OVAL

thE BLOB

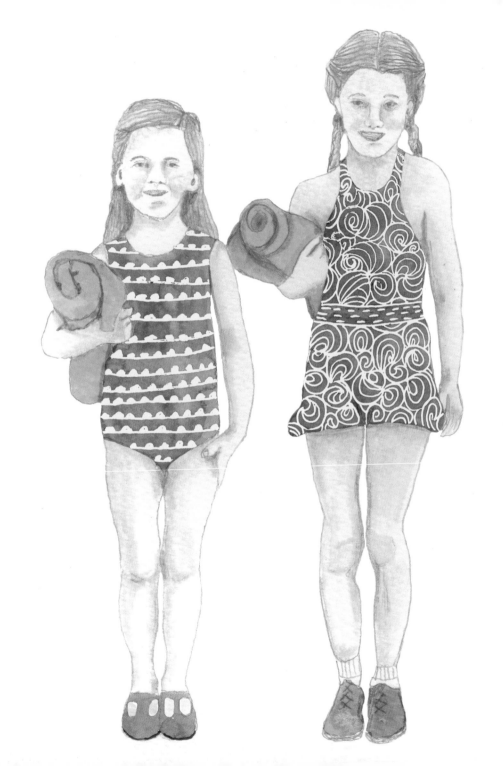

CHARLOTTE JILLEBA
88 YEARS OLD

"I am fascinated by the subject of swimming. I love to swim laps in a pool and hope to continue for many years." Charlotte, who now lives in Bogota, New Jersey, was born in the Bronx, New York. "I loved playing in water from an early age. At age nine I started to swim a sort of crawl mostly at the city pool in Crotona Park, Bronx." Later at Walton High School, Charlotte continued to swim. When she was 16 she swam one mile. "About a month later I was permitted to swim three miles." Between the ages of 20 and 50, Charlotte swam mostly at the shore on Long Island and New Jersey. In 1986, she joined the YMCA of Greater Bergen County and started swimming laps three mornings a week. "I love swimming laps and I'm drawn to this pastime sport because it invigorates and refreshes me. It also keeps my body in shape and helps my coordination! When I swim I am moving my entire body in good exercise. Swimming affords me friendship with other swimmers. I think it keeps me young at heart!"

NOTICE
LADIES
ON BEACH
MUST WEAR
BLOOMERS
CITY ORD 72

POOL

BEACH

NO
LIFEGUARD
ON DUTY

SWIM AT
YOUR OWN RISK

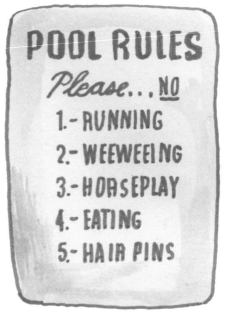

POOL RULES
Please... NO
1.- RUNNING
2.- WEEWEEING
3.- HORSEPLAY
4.- EATING
5.- HAIR PINS

WARNING!
— NO —
LIFE GUARD
ON DUTY

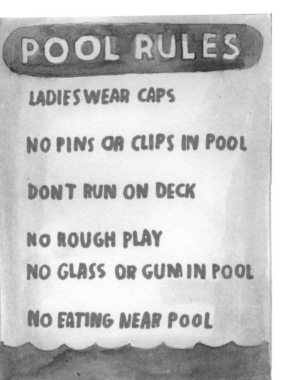

POOL RULES

LADIES WEAR CAPS

NO PINS OR CLIPS IN POOL

DON'T RUN ON DECK

NO ROUGH PLAY
NO GLASS OR GUM IN POOL

NO EATING NEAR POOL

← POOL

SWIMMING
POOL
CLOSED

JAPANESE SWIMMING POOLS

IN A JAPANESE POOL, YOU MOST CERTAINLY ARE REQUIRED TO WEAR A SWIM CAP— EVEN IF YOU ARE BALD!

IN SOME POOLS YOU ARE REQUIRED TO LOCK UP ALL OF YOUR POSSESSIONS & WEAR THE KEY AROUND YOUR WAIST WHILE YOU SWIM.

PUBLIC POOLS IN JAPAN DO NOT ALLOW PEOPLE TO SHOW TATTOOS. IF YOU HAVE TATTOOS, PLAN TO WEAR A SUIT THAT WILL COVER YOUR INK. SOME PEOPLE WEAR BANDAGES AS COVER.

WHEN ENTERING the LOCKER ROOM, LIKE ENTERING A JAPANESE HOME, YOU MUST REMOVE YOUR SHOES.

PUBLIC POOLS IN JAPAN SHOULD NOT BE CONFUSED WITH "ONSEN," WHICH ARE PUBLIC BATHS. SWIMMING POOLS ARE USED FOR LAPS OR WATER WALKING, WHILE ONSEN ARE USED FOR BATHING & RELAXATION.

EVERY HOUR the POOL IS CLEARED FOR SAFETY CHECKS AND LIFEGUARD CHANGES. the CHANGE IS SIGNALED BY MUSIC OR AN ALARM SOUND. POOL GOERS REST OR STRETCH FOR 10 MINUTES BEFORE BEING ALLOWED BACK INTO the WATER.

POOLS IN JAPAN ARE GENERALLY NOT FOR PLAY & MANY POOLS ARE RELATIVELY KID-FREE. IN FACT, MANY PUBLIC POOLS HAVE RULES PROHIBITING "HORSEPLAY."

JEWELRY IS FORBIDDEN At JAPANESE POOLS!

MANY POOLS HAVE AREAS JUST FOR RESISTANCE WALKING IN the WATER, WHICH IS BIG IN JAPAN.

KARLYN PIPES 53 YEARS OLD

Karlyn Pipes has been swimming competitively since she was small. "The smell of chlorine hit my nostrils, and I got so much encouragement from my instructors. I was hooked from the time I walked onto a pool deck," she says. Karlyn excelled, competing on record-breaking relay teams and winning Junior National championship titles until she was in her teens. The high school she attended had no girls' swim team so she competed on the boys' team and even won MVP one year. At 18 she had 15 scholarship opportunities and chose the University of Arkansas. But in the middle of her sophomore year, overwhelmed by the demands of competitive swimming and academics and attracted to the lure of boys and parties, she dropped out of school.

Karlyn calls the years between age 20 and 31 her "lost" years. She began drinking heavily, and her life spun out of control. For most of those years she drifted from job to job and between relationships and rarely got into the water. By the time she was 31 she had hit rock bottom. Karlyn's mom intervened. "You have an appointment with Doctor Nichols. And your appointment is at nine o'clock," she told Karlyn. That day Karlyn admitted she was an alcoholic and went into treatment. "The only way I can describe

my life at that time was putting on a pair of foggy goggles and trying to swim. I couldn't see anything. There is no future. There is no joy in life. But I decided to continue to live that way was worse than dying." She stayed in rehab for 10 days.

Five days after getting out of rehab, Karlyn got back in the water. Karlyn's previous relationship with water was about winning, which also brought up fear of failure. So she asked herself, "What if you never broke another record in your life? What if you can't swim a 100 free in under two minutes? What if you never win a race again? Are you okay with all of that?" The answer to all of these questions was YES, and she got back in the water.

Five months after getting out of treatment and back into the water, Karlyn had broken her first world record as a sober person, and that stream of wins didn't stop. Over the years Karlyn set over 200 world records. "The quest is about challenging myself to race the clock, not others. The records I set represent that I didn't quit. If I was going to do it, I was going to do it right." Karlyn also went back to college and swam competitively at age 35. Several years later she moved to Hawaii, where she started a swim school called Aquatic Edge, which she still runs today. Aquatic Edge is a "mobile" swim school, and Karlyn travels all over the world offering private instruction clinics, along with clinics and camps in Hawaii. She also gives inspirational talks across the globe to encourage others to never give up. "I use my gift to show women that you can reach your goals no matter what your age. Every day is a do-over if you want it to be. The records for me are the platform to share my true message of hope and recovery, and that we are so much more than our accomplishments."

tHE tRUTH I

ABYSS. ONE M

SWIMMING PO

DIVE FROM tH

SPRINGBOAR

INtO tHE DEPtHS

RISE AGAIN —

FIGHtING FOR BREAt

DOUBLY ILLUM

OF tHINGS.

ALWAYS AN
ISt—AS IN A
L—DARE tO
QUIVERING
OF tRIVIAL EVERYDAY
XPERIENCE AND SINK
N ORDER tO LAtER
AUGHING AND
— tO tHE NOW
NAtED SURFACE
FRANZ KAFKA

YOU CANNOT SWIM FOR NEW HORIZONS UNTIL YOU HAVE COURAGE TO LOSE SIGHT OF THE SHORE.

WILLIAM FAULKNER

Michael started swimming at age three. He learned to swim at the YMCA as a kid in Massachusetts. Today Michael swims year-round outside as often as he can, depending on the weather. "I sometimes swim through the skim of ice at Walden Pond. The sound of the ice breaking is like a symphony and the light reflecting off the crystals is amazing." At the age of 52, Michael went on a surfing trip to Costa Rica. There he picked up a parasitic infection that went to his central nervous system. Since then he has had several serious episodes of depression.

Cold-water swimming helps Michael to elevate and stabilize his mood. "I swim for survival. I love swimming. I swam myself back to health. The ocean is my church, and Walden Pond is my chapel."

MICHAEL
BRESNAHAN
65 YEARS OLD

MALIA VITOUSEK

24 YEARS OLD

Malia Vitousek grew up on the Big Island of Hawaii. Not surprisingly, she's been swimming and playing in the water for as long as she can remember. "So many memories have a pool or ocean as the backdrop. I can't picture my life without swimming. Even my name means 'calm water' in Hawaiian." Malia swam and played water polo competitively in high school. While she has always loved swimming, water polo is her greatest joy. "The sport was made for me. All those years wrestling with my brothers prepared me well." Malia attended Colorado College to play varsity water polo. But in the middle of her freshman season, she and her teammates were unceremoniously informed that the team would be cut for financial reasons. "It was devastating. We finished out our season and decided to start a club program." While her club program was strong, it wasn't enough for her. She missed the serious-ness and discipline of varsity sports, and was desperate to spend more time in the water. So she joined the varsity swim team her junior year and swam competitively for two years. "I was able to achieve much more than I ever thought possible in the pool." The water has been a constant in Malia's life, even after graduating from college. "There is no better place to think than head down in the water."

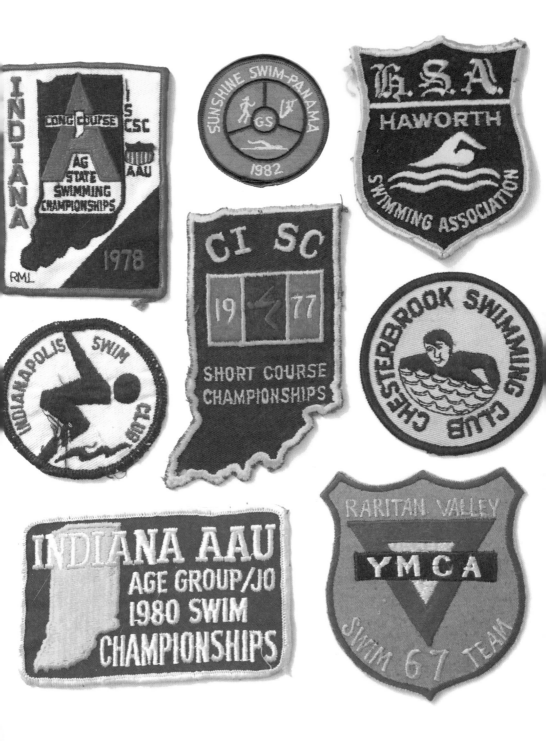

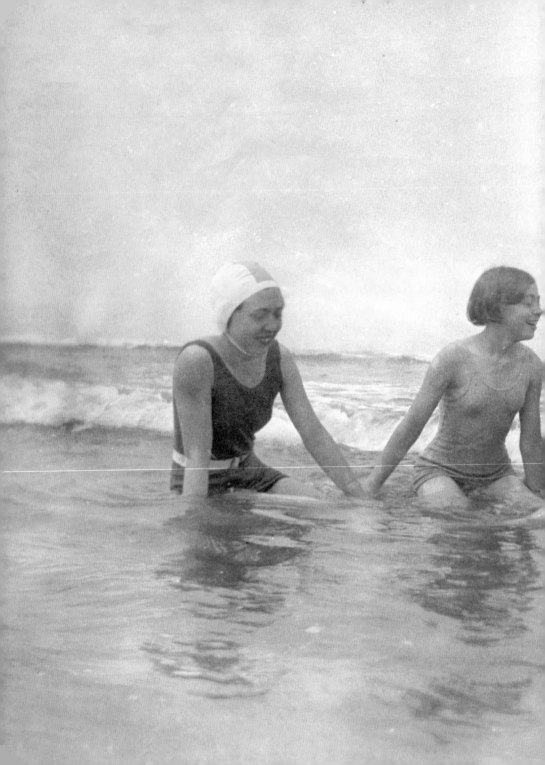

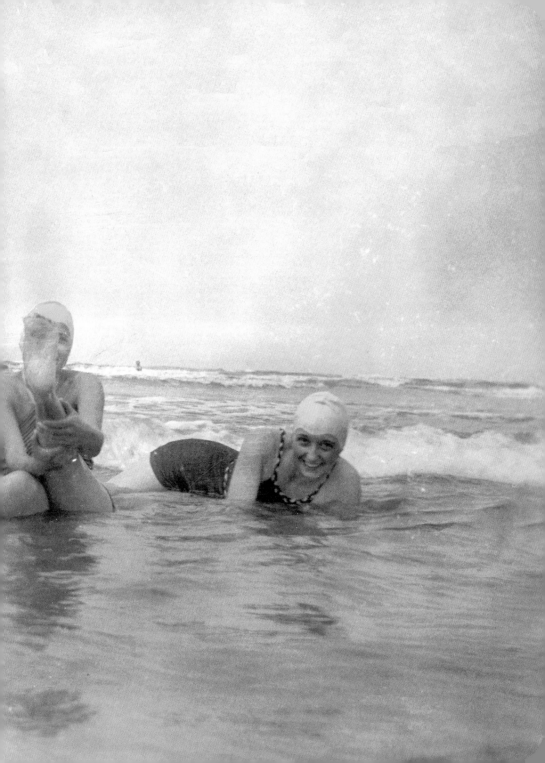

...PIC
SOM
ARf
th
STf
th
FEEL
AND
SAMI
yet

...RES ACHIEVE
...RING RARELY
...CULATED ABOUT
...METAPHYSICAL
...E OF SWIMMING:
...BODY, IMMERSED,
...AMPLIFIED, HEAVIER
...IGHTER AT THE
...IME. WEIGHTLESS
...STRONGER. LEANNE
 SHAPTON

JANELLE PIETRZK
34 YEARS OLD

"When I was 12 years old, I took a swimming class to improve my stroke, and the head of the fitness department suggested I join the swim team. I was never really good at sports, but I always loved to swim. I ended up swimming through high school on both club and high school teams." After a long hiatus after high school, Janelle got back into the water at the age of 34 and joined a Masters team. "I had just read the book *Swimming Studies* by Leanne Shapton, and it inspired me to start swimming again. In her book, she describes feelings about swimming that I had never thought about or even realized I also felt growing up as a competitive swimmer." Janelle, who is an artist, works from home in her studio, so going to swim practice gets her out of the house at least once a day. "I might never leave otherwise!" she jokes. "Being part of a team is great, since I don't have coworkers, and it is nice to feel the camaraderie." Janelle admits that she actually listens to her coach's advice and focuses on her technique far more than she did as a teenager. As a result, she is a better swimmer. And it helps her feel happier and more at peace. "Even if I am tired or in a bad mood, after about 10 minutes in the pool I've forgotten about work. It is a great meditation."

PATRICIA Y.C.E. LIN

46 YEARS OLD

Patricia's mother signed her up for swimming lessons at age five, and she has loved the water ever since. For over 10 years, Patricia has swum laps three or four evenings a week. "I feel so lucky to be able to do my workouts at UC Berkeley's Spieker pool. "It has 16 lanes, and I usually get a whole lane to myself!" Thanks to adult lessons, Patricia has learned to do a flip turn and has improved her stroke, body positioning, and kick. "Water soothes, heals, comforts, and both calms and energizes me."

It is also an important way that Patricia honors the many women in her life who have had cancer. She participates yearly in the Women's Cancer Resource Center Swim a Mile. The women she honors include her dear friend of 22 years Caroline Cox, her mother, and all five of her maternal aunts. Four of these aunts have died from cancer and her mother, and her remaining aunt are survivors. "I especially focus on my technique and training in the months before the event so I can do my best in honoring and remembering my loved ones."

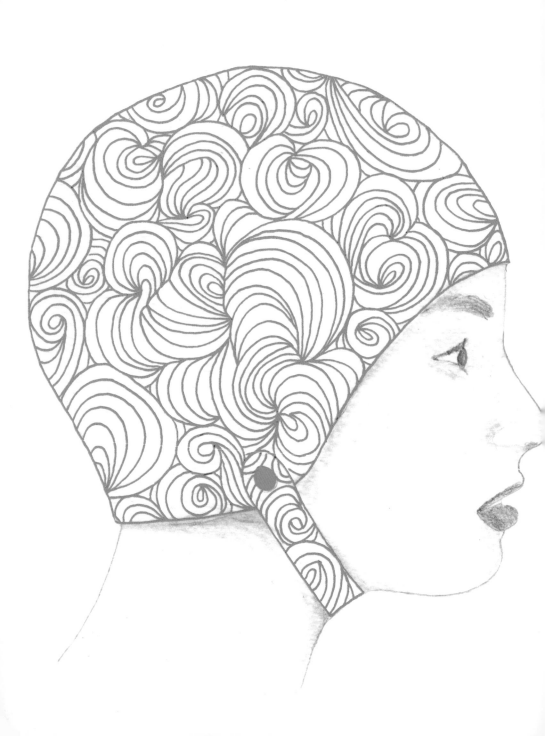

ROXANNE
WINSTON 27 YEARS OLD

Roxanne was eight years old when she first started taking swimming lessons at her local YMCA. "I was then introduced to competitive swimming by my teacher, Kevin Manley. The YMCA was located in a predominantly low-income neighborhood and offered low-cost sessions to kids in the community." At age 11, she followed Kevin to the city of San Diego USA–S team, which was an ethnically and socioeco-nomically diverse team. "I really appreciate that this was my intro-duction, because I swam with people who looked like me or shared my background. As I grew older and started to interact with other swimming spaces, I could see what a rare experience that truly was. I think part of me is proud to be a swimmer because it's a lifesaving skill everyone should have access to, and the more black swimmers or swimmers of color stay in the sport, the more young ones will feel like they belong and feel inspired to join the sport."

Roxanne currently swims for Tsunami Masters Team in San Francisco, and her teammates remind her of why she swam for so long on her youth team. "There is a camaraderie amongst my teammates that is hard to find in other places. I get to share a lane with a doctor, a pro-gram coordinator, a tech designer, and a hair stylist. I don't have the opportunity to interact with such a wide swath of people as I have on this team."

Roxanne also loves the water, which washes away the stresses of her everyday life. And she loves swimming for the same reasons some people do not. "My years of swimming fostered a love for the smell of chlorine. I love swimming back and forth, lap after lap, losing myself in the count, singing songs to myself, meditating on the feel of the water as it flows over my body."

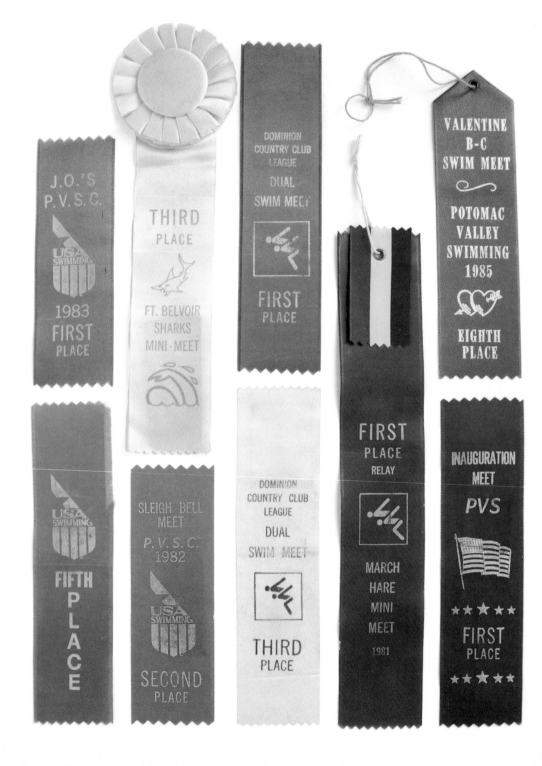

MAYA KAHN
13 YEARS OLD

Maya was born with achondroplasia dwarfism. "I grew up right by the beach and had a pool in our backyard, so I was first in the water at just a few months old." Maya started to compete in summer swimming league when she was about eight, and has been competing ever since. Maya's biggest accomplishment as a competitive swimmer so far was gaining eligibility to go to the Can-Am Paralympics Championships in Miami for the first time last year, and she just competed again this year in Toronto. "Once I am in the water everything else at that moment just goes away. My body goes into autopilot, and I just let myself swim. I also love swimming because I get the opportunity of meeting so many different types of people with all different kinds of disabilities at the swim meets that I go to around the country." Maya's long-term goal is to make the Paralympic team. "I am training for Tokyo 2020 at the moment, and I am very anxious to see where swimming takes me next!"

GLOSSARY

AAU (Amateur Athletic Union): One of the largest nonprofit, volunteer sports organizations in the United States, dedicated exclusively to the promotion and development of amateur sports and physical fitness programs.

event: A race of a particular stroke over a specific distance. An event can include one preliminary race and a final race.

FINA (Fédération Internationale de Natation): The international rule-making organization for the sport of swimming.

heat: A group of swimmers entered in a particular event. Since most pools only have six to eight lanes and there are more than six to eight swimmers in an event, many events have more than one heat (Heat 1, Heat 2, Heat 3, etc.).

IM (Individual Medley): A combination of the four different swimming strokes (butterfly, backstroke, breaststroke, and freestyle) swum in one race. The medley can also be swum as a relay by four different swimmers, each swimming one stroke.

Junior Nationals: A U.S. championship meet for swimmers 18 years old or younger. Swimmers must qualify to compete.

lane: The specific area in which a swimmer is assigned to swim in a race or at a workout. Lanes are typically designated by plastic "lane lines" strung across a competition-size pool.

nationals: USA Swimming National Championship; swimmers must qualify to compete.

Olympic Trials: The long-course swim meet, sanctioned by USA-S (USA Swimming), that is held prior to the Olympic Games to determine which swimmers will represent the United States on their Olympic team. Swimmers must qualify to compete.

Open-water swimming: Races and workouts that take place in outdoor bodies of water such as oceans, reservoirs, lakes, and rivers.

Paralympic swimming: Swimming events for athletes with a range of physical disabilities, including impaired muscle power, impaired passive range of movement, limb deficiency, leg length difference, short stature, hypertonia, ataxia, athetosis, vision impairment, and intellectual impairment. The Paralympic Games are a major international multi-sport event that includes swimming.

pool deck: The area around a swimming pool.

relay: A swimming event in which four swimmers participate together as a "relay team." Each swimmer completes an equal portion of the race. There are two types of relays: the medley relay and the freestyle relay. Relays of distances exist, from 100-meter relays (for kids) to 800-meter relays.

split: A segment of a swimming event. For example, a swimmer's first 50-meter time is taken as the swimmer swims during the 100-meter race, and that time is the swimmer's "split."

swim meet: A series of swimming events held in succession over the course of one to several days, usually in one location.

USA-S (USA Swimming): The governing body of swimming in the United States.

USMS (United States Masters Swimming): A national membership-operated nonprofit organization for adult swimmers 18 and up. There are also Masters swimming organizations in Canada, Australia, and Europe.

yardage: The distance a person swims in practice. Total yardage can be calculated for each practice session (for example, 4,000 yards or 4,000 meters).

YMCA (Young Men's Christian Association): A worldwide nonprofit organization with branches in many communities. Many YMCA organizations have swimming pools and offer swimming lessons and Masters swimming opportunities.

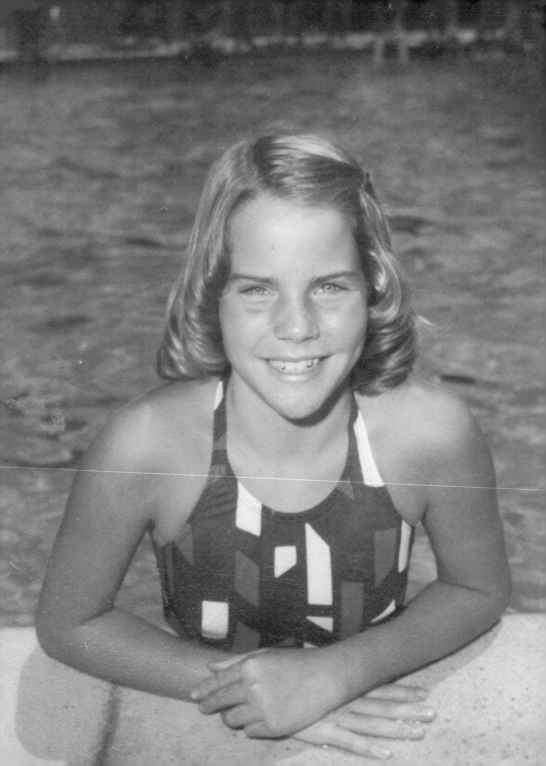

ACKNOWLEDGMENTS

First and foremost, I would like to thank my editor at Chronicle Books, Bridget Watson Payne, without whom this book would not exist. You have become my most treasured collaborator and I am ever grateful for your endless confidence in me. Your vision for this book has given me wings. To my designer, Kristen Hewitt, for always making my drawings shine brightly. Working with you over the past eight years has been one of my most cherished professional experiences. To Caitlin Kirkpatrick, for impeccably managing every last detail of this book. To my literary agent, Stefanie Von Borstel, for being the most kind, smart, and resolute shepherd I could wish for. To my research assistant, Malia Vitousek, for your fantastic contributions and enthusiasm. To my dear friend, Anne Ditmeyer, for your research on my behalf and your passion for this project. To foreword writer Lynne Cox, for your inspiring words. You have been a hero of mine for many years, and it is a true honor to have you on these pages. To my sister, Stephanie Congdon Barnes, for being my ever-present stalwart reinforcement and for helping me to photograph the collections in this book. To every one of the swimmers I interviewed and profiled in this book, your stories are more moving than I ever imagined possible and speak so poignantly to the universal power of swimming as a healing and joy-filled force in our lives. To everyone near and far who connected me with fellow swimmers, sent me links and information, and provided me with images and ideas. To the swimming community at large and to every coach, teammate, and fellow swimmer who ever encouraged or challenged me in the pool. Last, to my wife, Clay Lauren Walsh, for helping me in countless ways with this book, and for your unending support, energy, and devotion. I love you to the ends of the earth and over every ocean and back again.

CREDITS